YORK
in the 1950s
Ten Years that Changed a City

PAUL CHRYSTAL

AMBERLEY

Front cover illustration: Busy Ouse Bridge in 1959 with Boyes in the background. (Picture reproduced courtesy of *The Press*, York www.thepress.co.uk)

Back cover illustration: Busy day at the City Art Gallery car park in 1958. (Picture reproduced courtesy of *The Press*, York www.thepress.co.uk)

To Anne – a child of the '50s

First published 2015

Amberley Publishing
The Hill, Stroud
Gloucestershire, GL5 4EP

www.amberley-books.com

Copyright © Paul Chrystal, 2015

The right of Paul Chrystal to be identified as the Author
of this work has been asserted in accordance with the
Copyrights, Designs and Patents Act 1988.

British Library Cataloguing in Publication Data.
A catalogue record for this book is available from the British Library.

ISBN 978 1 4456 4059 4 (print)
ISBN 978 1 4456 4092 1 (ebook)

Typesetting and Origination by Amberley Publishing.
Printed in Great Britain.

CONTENTS

INTRODUCTION

There are many books published on York of yesteryear, but none that focus on what was going on in this historic city in one particular decade. This book is the first in a series that will also take in York in the '60s and York in the '70s. It provides a perceptive and authoritative survey of York life in the 1950s – a formative decade in which the city began to shrug off the privations and austerity of the Second World War and build for the future, emerging to form the great city it is today. Much of what we now see, enjoy and cherish in York owes its origins to work worked and plans planned in the 1950s.

The post-war renaissance and rejuvenation began with the marvellous festival of York in 1951, during which a performance of the Mystery Plays showcased to the world the historical essence of the city. The York Development Plan was getting under way to shape our transport infrastructure and much-needed housing development. Schools were built and health services modified to coalesce with the needs of the fledgling NHS; industry was responding to the needs of a resurgent building programme and chocolate, and the railways were enjoying some of their golden years.

York in the 1950s explores all of these aspects of York and much more, in that decade of reconstruction and renovation. Whether you grew up here then, whether you have left and want to rekindle your childhood and teenage memories, or whether you are just a child of the '50s and want to see how it all happened in this most historical of cities, this book will amuse, fascinate and inform with its wealth of information, rarely seen photographs and its sheer optimism.

1

1950s Britain

Typically, 1950s Britain was a grey decade, characterised by grainy black-and-white life as the country slowly emerged, as if from hibernation, into a post-Second World War world still benighted for much of the time by rationing, bombsites and unadulterated austerity. Yet among all that bleakness there was still hope, marked by two events full of optimism and happiness – the uplifting coronation of Queen Elizabeth II and the wonderful Festival of Britain in 1951, 'a tonic to the nation'. This festival showed us how we *could* live, especially with exciting and revolutionary new ways of dressing, entertainment, furnishing and decorating our houses, it spotlighted the remarkable progress we were making in science and industry, and it highlighted and showcased our arts as never before. York's contribution was the spectacular York Festival, which included a revival of the York Mystery Plays – the first since 1570. The Guidebook to the Festival described its legacy as follows:

> It will leave behind not just a record of what we have thought of ourselves in the year 1951 but, in a fair community founded where once there was a slum, in an avenue of trees or in some work of art, a reminder of what we have done to write this single, adventurous year into our national and local history.

Fashion, liberated from the corseting constraints imposed by rationing, became more exciting and eye-catching. Ten million people paid to get into the six main national exhibitions over five months, the most popular event being the South Bank Exhibition with almost 8.5 million visitors, over half from outside London. Eight million visitors went to the Festival Pleasure Gardens while the Festival Ship HMS *Campania*, which docked in ten port cities, was visited by 900,000 people. If 1950s Britain and 1950s York aspired to a better future, they certainly got it from the Festival of Britain – in spades.

There were other flashes of technicolour amid the grey – the accession of Queen Elizabeth II and her subsequent marriage generated hope and optimism for the years to come, as witnessed first-hand by huge numbers of people on that dazzling new living-room entertainment phenomenon, the television.

The post-war 1940s and early '50s were indeed years of unremitting austerity, but by the middle of the decade economic growth had picked up. War had

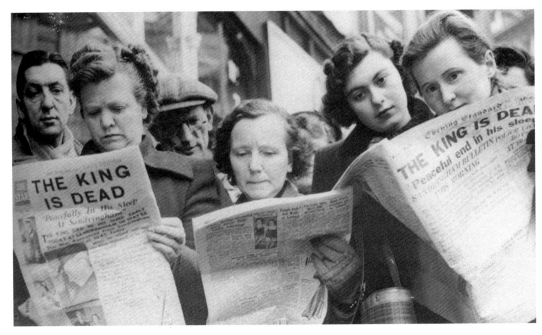

Bad news, good news – the King is dead; long live the Queen!

caused debts of a massive £3,000 million and exports had slumped to one third of their pre-war levels. The huge benefits and advantages afforded by Land Lease were suddenly wiped out by our former allies, the USA. Nevertheless, the numerous capital projects and the increasing output from our factories led to a demand for skilled labour. These workers commanded plump wages that in turn led to a period of relative affluence for the fortunate ones. In 1951, the average weekly income of a man aged over twenty-one was £8.30 per week. This had nearly doubled in 1961 to £15.35, tempered slightly by inflation, which between 1955 and 1960 averaged 15 per cent. Nevertheless, weekly wage rates rose 25 per cent between 1955 and 1960. In addition, the prices of small cars, TVs and white goods were coming down. Disposable income was at a high, so much so that Harold Macmillan was able to capture the spirit of the age when in 1957 he felt confident enough to famously proclaim 'Some of our people have never had it so good'. Some, not all.

Not exactly a new age of prosperity then, but things were certainly on the up. There was a boom in housing and unemployment was low. Britain was, by and large, a healthier place to live, now reaping the benefits of the infant NHS and other welfare programmes. The introduction of vaccinations for tuberculosis in 1953 and polio in 1955 banished the spectre of these diseases for most. Around 98 per cent of all children were getting free school milk in 1950 and infant mortality fell below 30 per 1,000 for the first time ever. This was all in spite of the exciting freedom enjoyed by the child of the '50s and a virtual absence of the protection smothered on children compared with today. Children's mothers were likely to smoke and drink while they were in

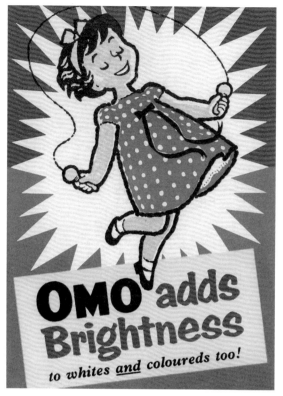

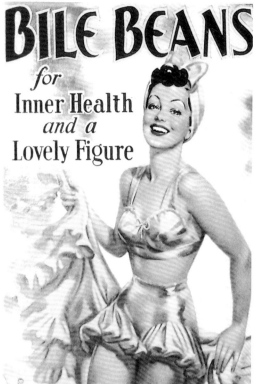

Typical 1950s advertising. Bile Beans had been popular since late Victorian times and were manufactured by C. E. Fulford Ltd. There is of course still a striking painted Bile Beans wall advertisement in Lord Mayor's Walk in York. Bile Beans were the perfect solution for biliousness, headache, indigestion, constipation, piles, debility, female weakness, dizziness, sallow complexion, pimples, impure blood and liver, stomach and bowel troubles. My late mother used to take two religiously every day, with little noticeable effect. We, meanwhile, were dosed daily on Haliborange. Omo was one of the many brands of washing powder to go with your new washing machine; others included Daz, Dreft and Persil. The Frigidaire poster is in the Castle Museum. (Image courtesy of York Museums Trust, www.yorkmuseumstrust.org.uk/)

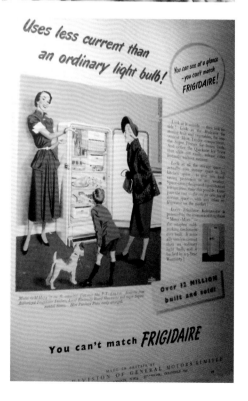

the womb and, when those children emerged, they were probably living in a room in which their mothers and fathers smoked; their cots and prams were covered in lead-based paints, as were their toy soldiers; their medicine came in easily-opened bottles and was stored in accessible cupboards; they rode bikes without a thought for a helmet; they played football on rock-hard ground; their playgrounds were made of concrete and what cars they rode in lacked seatbelts or had airbags that trapped endlessly circulating cigarette smoke. But the child of the '50s was free to climb, jump, chase, build dens, light bonfires, wade in becks in search of sticklebacks, jump on the back of slow-moving guard-less goods trains and fight, come rain or shine. Not so many of these carefree and tearaway children were overweight (just big-boned or well built), despite the jam and cream cakes, fish and chips, dripping, suet puddings, pies, full milk with cream crowning the bottle, endless sugary sweets, crisps with at least one little blue bag full of salt, and real butter on their white bread. Sooner or later, cigarettes became the norm for many because they had been well schooled with Barratt's sickly sweet cigarettes – that flaming red end – and liquorice pipes with which to mimic their mothers and fathers. On the minus side, in a world where golliwogs were usually nothing more than a cherished cuddly toy (and not an issue), along with daft looking Big Ears, fat Billy Bunter or ugly Plug, the child of the '50s was nevertheless subject to some high levels of corporal punishment, often in the shape of a thick ear, a clout, a tanned hide or a heartily slapped top of the leg.

Most working-class communities managed to stay together, with extended families living in close proximity in spite of the largely welcome rehousing and slum clearance programmes. Nevertheless, in 1951, there was still a housing shortage of a million and a half dwellings. This inevitably led to married couples living at their parents' houses (usually the wife's parents), where mother or mother-in-law continued to hold sway. Housing for the working classes was, by our standards and expectations, still shocking in 1951 when one third of all Britain's houses had no bath. Large houses had been converted into one-bedroom flats for families, with shared facilities on the landing. The dank, dark and dilapidated back-to-backs and two-up two-downs with shared lavatories in the yard were still very much in evidence.

Marriage remained popular during the 1950s with little change in the proportion of people married to unmarried between 1951 and 1961. The tragic depredations of the war, though, continued to be felt with its contribution to the high figure of widowhood compared with the number of widowers. In 1951, 944 men were widowed or divorced compared with 2,769 women. Birth rate per thousand of total population went up from 16.0 per cent in the early '50s to 17.9 per cent in 1961. From time immemorial, the number of women in the British population had exceeded the number of men in the fifteen to twenty-nine age group. In 1951, women and girls totalled 5,255,000 and men totalled 5,073,000. Indeed, to paraphrase Macmillan, men never had

it so good. However, by 1961, men took over with a population of 5,159,000 compared with 5,100,000 for women.

The vagaries of our electoral system were well illustrated in the 1950s. The astounding Labour victory of 1945 (48 per cent to the Conservatives' 39.6 per cent) was overturned in 1950, although more people voted Labour (46.1 per cent) than did Conservative (43.5 per cent). Indeed, more people voted Labour in 1950 than did in 1945. In 1951, Labour won 48.8 per cent of the vote, 0.8 per cent more than the Conservatives who won a parliamentary majority. The Conservatives remained in office for the rest of the decade and into the early '60s.

The ending of meat rationing in 1956, heralding the end of post-war rationing altogether, marked the dawn of the age of consumerism. The two world wars had, out of necessity, provided women with employment opportunities hitherto denied to them. However, in the '50s the norm was still for women to stay at home, look after any children and keep the household running smoothly and efficiently for the family – in particular for the wage-earning husband on his return from the day's (or night's) work. But help was at hand. Slowly but surely, labour-saving goods, particularly white goods, were becoming, if not universal, then certainly more common: in the 1950s, the typical home, wife or mother could boast a cooker, vacuum cleaner and an electric fire (to supplement the coal fire in the living room). A third of families had the benefit of a washing machine, while the other two thirds still scrubbed and wrung laboriously by hand. There was still a long way to go, though. In 1956, only 8 per cent had a fridge or freezer (although this had risen to 33 per cent in 1962), while tumble dryers were still a thing of the future. Subscriber trunk dialling was introduced in Bristol in 1958 and London in 1961. In 1951, 1.5 million houses boasted a telephone, however, outside telephone boxes, queues and ready change that came with them were still the norm for most people. Toilet paper (as opposed to yesterday's newspaper) caught on quickly. Frozen fish fingers were an early sign of convenience foods, easily and rapidly prepared. At the end of the decade, such convenience foods accounted for 20 per cent of all food expenditure; by 1970 this had grown to 25 per cent.

On the leisure front, ink and fountain pens were still scratching away. Some people listened to 78 rpm gramophone records when they were not mesmerised by the television. The wireless was still very popular. If there was one event that changed British family life forever, it was the televised coronation of Queen Elizabeth II on 2 June 1953 at Westminster Abbey, a unique occasion which, for the first time, allowed the public to watch the event live almost as if they were there themselves. Two-thirds of homes with 5 million viewers now owned a television (up from 14 per cent in 1952), making do, of course, with the one black-and-white channel from the BBC, which went out on a restricted basis. At least 2 million people turned out on the streets to watch the spectacle, but a further 20.5 million (56 per cent of the adult population) were glued to it on television, and a further 32.7 per cent, or 11.7 million, heard it minute by minute on the wireless. Normally, television viewing hours were limited

deliberately to prevent children becoming addicted and to stop their parents neglecting their 'duties'. A commercial TV channel followed in 1955 with a multitude of adverts.

Televisions in those days, of course, were an age away from the sets we enjoy today. They were essentially large, bulky wooden cabinets housing a tiny 9-inch screen. This created the need to accessorise the 'telly' with a thick magnifier, strategically placed at the front of the screen. Signal, though a *sine qua non*, was often a problem, which necessitated one of the viewers to act as a mobile aerial as he or she walked around the room to locate something that translated into a picture.

In its early days, the BBC was notoriously highbrow and earnest. ITV changed all that with more populist fare, including *Take Your Pick, Emergency Ward 10, Double Your Money, Opportunity Knocks, Sunday Night at the London Palladium* and *The Adventures of Robin Hood. I Love Lucy* was successfully imported from the States in a flash of programming genius, which opened the floodgates for more and more in the years to follow. 70 per cent of BBC's viewers deserted to ITV, forcing the BBC 'downmarket' to some extent, and leading to more accessible programming, which took in *Hancock's Half Hour, Dixon of Dock Green, Laramie,* and *This is Your Life*. Children watched with mother and enjoyed *Flower Pot Men, Sooty* and *Muffin the Mule*. The bestselling toy of 1954 was the (sometimes) tuneful Sooty's Xylophone. By 1961, the gogglebox had inveigled its way into the corner of 95 per cent of all homes, usurping the wireless as the centre of attention and the fireplace as the focus of family life.

Wireless programming had its serious side too. In January 1952, this was shown by the Light Programme Broadcast Notes from America and the *Archers*, but the Home Programme provided relief with *Children's Hour, Have a Go!* and *Ray's a Laugh*.

The first episode of *The Archers*, 'an everyday story of country folk', was aired on 1 January 1951 (the pilot aired in 1950). It has since clocked up nearly 18,000 episodes and is the world's longest-running radio soap opera. Five 15-minute episodes were transmitted each week, at first on the BBC Light Programme and then on the BBC Home Service. It was originally produced with help from the Ministry of Agriculture, Fisheries and Food to impart information to farmers and smallholders to help increase productivity in the post-war years of rationing and food shortages.

Words new to the dictionaries were 'stoned' in 1952 and 'rock 'n' roll' in 1953. Confectionery companies were among the first advertisers on commercial television. By 1958, 60 per cent of the advertising budget for chocolate went on television commercials. There were some very memorable TV slogans: Murraymints, 'the too-good-to-hurry-mints', and Rowntree's Fruit Gums, 'don't forget the fruit gums, mum.' Rowntree's polar cool Polos were 'the mint with the hole'. In 1957, Rowntree's again invited us to 'have a break ... have a KitKat'. In 1955, Mars was still telling us that not only was a Mars Bar good

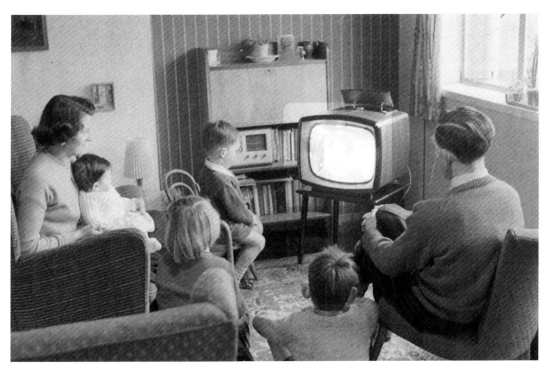

Television – the new focus of the living room and of '50s family life. Note the books and the wireless too.

for your work/life balance, but it also 'feeds you goodness 3 good ways: milk, chocolate, glucose'.

Because supermarkets were few and far between, with Sainsbury's and Tesco only just beginning to lead the way in the early years of the decade, most food shopping was still done on a day-to-day basis at local shops such as the grocers, butchers, bakers, fishmongers and the like. As we have seen, fridges were still a rarity so food was stored in a cool pantry or larder and had to be bought fresh. The daily shop was supplemented by meals on wheels – grocers, bakers and other such mobile shops that delivered their goods direct to the housewife's door. Fresh milk came early every morning on a horse and cart or on a virtually noiseless motorised van, the sound of which was unique and forever memorable. Fresh fruit and vegetables were sourced mainly from Britain's farms, market gardens and orchards because refrigerated transportation was unknown. Seasonal produce such as strawberries and plums would be available in the shops for just a few weeks in the summer. No fresh peas, beans or salads vegetables could be obtained throughout the winter, although tinned varieties were always to hand.

The 1950s saw the start of the move towards fashionable boutiques – notably in London where Mary Quant opened her first Bazaar in the King's Road and John Stephens threw open the doors of his first shop in Carnaby Street. Although more of a '60s phenomenon, this was the start of a reaction to the limited variety and choice espoused by big chain department stores, corporate

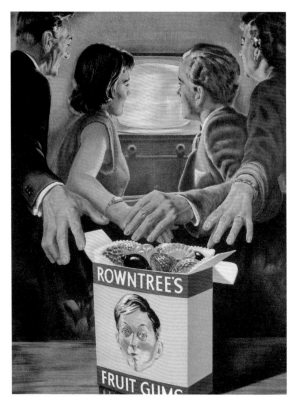

More '50s advertising. Rowntree's, 1956. The fruit gums no mum could ever forget, thanks to the adverts. Fruit gums in a tube were flat; those in the boxes were fruit shaped. Note the captivating TV in the background.

advertising campaigns and branding. In addition, it introduced what Arthur Marwick calls 'a *soupcon* of continental dash' – a slow but much-needed injection of colour, flair and inclusiveness that eventually permeated provincial towns in the '60s. The market was young people – an increasingly vital sector from the '50s onwards.

During the 1950s, betting was heavily regulated and restricted, but the 1960 Betting and Gaming Act changed all the that, allowing betting shops to open on the high street, bringing gambling out, to some extent, from the shady underworld and eliminating the illegal practice of passing betting slips. Bingo and gaming clubs followed, but the best thing was surely the introduction of the first public lottery since the eighteenth century in 1956 – the Premium Saving Bonds Scheme.

Attitudes to aspects of sexuality were still very conservative. In 1952, homosexuality was still illegal. It was not until the Sexual Offences Act 1967 that homosexual acts in private between two men aged twenty-one or over were decriminalised. Even then the Act applied only to England and Wales and excluded the merchant navy or the armed forces. Alan Turing, of course, is famous for the intelligence work he did at Bletchley Park, not least in cracking intercepted coded messages transmitted by the Germans, and helping to shorten the war, saving countless lives. In January 1952, the thirty-nine-year-old Turing was in a relationship with Arnold Murray, a nineteen-year-old unemployed man.

During an investigation relating to a burglary at Turing's house (committed by an acquaintance of Murray's) he admitted to a sexual relationship with Murray; both men were charged with gross indecency. Turing was convicted and given the choice between going down and probation, which was conditional on his being subjected to hormonal treatment designed to reduce his libido. This involved injections of stilboestrol administered over twelve months. The treatment made Turing impotent and caused gynaecomastia (enlargement of the breasts). At the time, Turing predicted that 'no doubt I shall emerge from it all a different man, but quite who I've not found out'. Murray was given a conditional discharge. Turing's conviction barred him from his cryptographic work at GCHQ. In those Cold War days there was concern about homosexual entrapment of spies by Soviet agents, made worse by the recent exposure of Guy Burgess and Donald Maclean, as KGB double agents.

The Obscene Publication Act of 1959 was 'an Act to amend the law relating to the publication of obscene matter; to provide for the protection of literature; and to strengthen the law concerning pornography'. It was used in two high profile cases in the 1960s – the trial of Penguin Books for publishing *Lady Chatterley's Lover* and *Oz* for the 'Schoolkids' issue. The Street Offences Act 1959 was an attempt to reduce street prostitution, under which 'It shall be an offence for a common prostitute to loiter or solicit in a street or public place for the purpose of prostitution.' The penalty for living off immoral earnings was increased to a maximum of seven years' imprisonment.

People did a lot of reading, either from books or magazines. Cheaper paperbacks became more commonly available and affordable. The place to go for books, except bookshops, were the circulating libraries and local two-penny libraries until their demise in the early '60s when they were usurped by local public libraries and by lower prices of books. Nevertheless, WHSmith's library survived until 1961 and Boots Book Lovers' Library survived until 1966.

Popular hobbies included knitting and sewing for women, and gardening for men. Sewing often meant mending and gardening usually meant providing one's own fruit and vegetables. Children played out a lot more, safely doing exciting and occasionally naughty things that would horrify many overprotective mothers today. Stamp collecting was all the rage, providing invaluable subliminal education in geography, history and nature. Much time was still spent playing family board games like Monopoly, Ludo, Tiddly Winks and Snakes & Ladders, with all the harmony and goodwill they generated between siblings. Yo-yos, 3D-specs, I-Spy books, fishing nets, hop-scotch and hula hoops all enjoyed their crazes in 1950s. Catapults, homemade bows and arrows with their sharpened tips, whip and tops, marbles (and ball bearings), itchy powder and kiss chase were never confined to just the Dennis the Menaces or Minnie the Minxes of the world. With the Second World War still fresh in the memory, cap guns, ray guns, rifles, whittled sharp swords, cowboy and Indian outfits, strangulating lassoes and toy soldiers were ever popular. 'Jerries' and 'Japs' were still the enemy; less bellicose were the Dinky,

Corgi and Matchbox cars and Meccano. Lego built a strong following, Scalectrix did its endless laps, Subbuteo continued to score and Scrabble was the word. Train sets puffing smoke and dolls, with their houses and play-kitchens were ever popular. Mondays brought a raft of comics and the choice by the end of the decade was huge: *Topper, Eagle, Lion, Rover, Beezer, Dandy, Girl, Bunty* and *Sunny Stories*, to name just a few, were fought over, reread and swapped.

The popular pre-war seaside holiday resorts were invaded once again by the middle and working classes. The latter spent their savings on holiday camp holidays – recently the preserve of the lower-middle classes. Contemporary theatre saw a resurgence led by exciting new playwrights such as John Mortimer, Arnold Wesker, Peter Schaffer and Harold Pinter. The rebellious Teddy boy appeared menacingly on the social scene. In 1951, Smith, Klein & French launched Drinamyl, or purple hearts. LSD was used therapeutically rather than recreationally; its time was to come in the '60s. Coffee bars with their juke boxes and pinball machines became *the* place to go. Ballrooms catered much more now for younger people with Friday and Saturday night dances.

The espresso machine was invented in 1945 by Achille Gaggia in Milan and spread to coffee houses and restaurants across the rest of Europe and North America in the 1950s. Another Italian, Pino Riservato, opened England's first espresso bar, the Moka Bar, in London's Soho in 1952. By 1956, we had 400 or so espresso bars.

Reported crimes of violence steadily rose by 6 per cent a year to 11 per cent a year from the mid-1950s – 5,869 cases in 1956 to a staggering 11,592 in 1960. Were these statistics representative of actual crime, more reporting or better policing?

The cinema and football were consistently popular, with one third of people going to the 'flicks' at least once a week from 1946. Smoking and 'courting' were part of the experience and the little ashtrays, the blue haze of smoke caught in the projector's probing search light, the double seats, snogging and heavy petting remain unforgettable memories to many. Peter Sellers, Ealing comedies, *On the Waterfront, Ben Hur, The Bridge on the River Kwai, Some Like it Hot, Singin' in the Rain* and Hitchcock's *Vertigo* were just a few of the many hugely popular films. The 1955 film *Blackboard Jungle* was a movie that was largely responsible for the seismic revolution in popular music. It featured Bill Hayley and the Comets' unforgettable 'Rock Around the Clock', which did much to popularise rock 'n' roll and became a catalyst for riots when it was shown around the country. In 1956, Teddy boys ripped up seats and danced in the aisles in a London theatre. This was the shape of things to come. James Dean (the *Rebel Without a Cause*) did nothing to placate the rising tide of rebellion amongst disaffected sections of Britain's youth, with the release of his influential film in 1955. Many people think that 3D films are a twenty-first-century phenomenon, but actually the 1952 film *Bwana Devil* with its man-eating lions jumping out at you pioneered 3D. The glasses often caused headaches and the emergence of widescreen

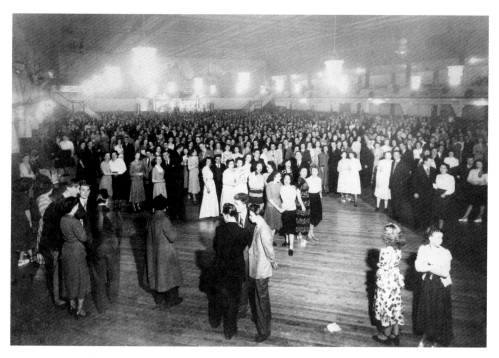

Above: A typical 1950s night out at the dance hall. This particular scene shows a group of young men hesitating before they pounce at the Queen's Rink ballroom in West Hartlepool.

Below: Wilf Mannion, one of Middlesbrough FC's greatest stars, practicing dribbling with some boys in the backstreets of Middlesbrough, originally published in *Picture Post*, 3 November 1951.

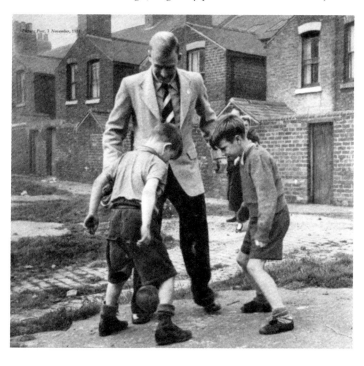

Cinemascope killed it off for another fifty or so years. Then, on 24 September 1957 came Elvis Presley with 'Jailhouse Rock', written and composed by Jerry Leiber and Mike Stoller to coincide with the release of Presley's film of the same name.

Trade union membership remained steady. In 1951 it stood at 7,745,000 for males (56 per cent of working males), by 1961 it was 7,911,000 (53 per cent). For women it was 1,790,000 and 2,005,000 (25 per cent and 24 per cent respectively). Militancy, though, had started its ominous rise with an annual average of 2,073,000 days lost in 1,791 strikes involving 545,000 workers between 1945–54. For 1955–64, the annual averages were 2,521 strikes involving 1,116,000 workers, losing 3,889,000 days.

At school the eleven-plus examinations somewhat clumsily sorted pupils out into rigid categories, a classification that often compartmentalised them for the rest of their lives. The results of the exam were intended to determine a child's secondary school destination, matching their abilities and future career needs with either a grammar school for the supposedly bright, secondary modern for the seemingly less bright, or a technical school for the less academic/more practically minded. Three short tests often wrote your remaining life story; a grammar school education was usually most likely to see you go on to university.

Corporal punishment was still on the curriculum with weapons of choice ranging from swiping cane, stinging strap, knuckle-rapping ruler and flying blackboard rubber. The tedium of lines was a constant. Prefects were often objectionable and just as feared as teachers. School dinners were universally repellent and staffrooms were often invisible in a fog of cigarette smoke. PT lessons were hideous, cold, wet and undignified for many. Girls wielded needles and bobbins in needlework and operated weighing scales and saucepans in domestic studies, while boys welded metals and fashioned dovetail joints. Bunsen burners and calorimeters were shared by both sexes. For some, school in the 1950s was the best days of their lives, for others, nothing of the sort.

More disposable income was enjoyed by younger men and women as well. Indeed, teenagers (a phenomenon of the '50s) had money to spend. Much of this went on the latest fashions, often regarded as outlandish by their parents, or else on buying records and record players (notably the Dansette) so that they could enjoy the latest in rock 'n' roll and rhythm and blues as it trickled through from the United States. Pirate radio stations enjoyed their heyday in the 1960s, but, under the covers, Radio Luxembourg had been around since the 1930s. In the '50s it began to provide an exciting and vibrant (and illegal) antidote to the anodyne BBC radio music programmes bringing in Bill Haley, Elvis Presley and the like. The cinema continued to be a popular night out and an essential rendezvous for those teenagers who were 'courting'. Saturday was an unmissable time for the many boys and girls who flocked to the matinees. The unchallenged heroes then were Tonto and the Lone Ranger, Zorro and Davy Crockett – all revolutionaries or heroes. Voting age was still twenty-one.

Car ownership more than doubled in the 1950s. By 1955, there were over 3 million cars on Britain's roads. The age of the motorway, bypass, car park, ring road and traffic jam had dawned. Competency tests to drive a motor car introduced in 1934 were suspended in 1956 for one year because of the Suez Crisis, to allow examiners to work at petrol rations. Only the Queen was exempt from the test. In 1950, the pass rate for the driving test was 50 per cent, tubeless tyres appeared in 1953, diesel cars and fuel injection followed in 1954 and the driving test fee doubled to £1 in 1956. The Preston bypass was completed in 1958 on the M6 and was Britain's first stretch of motorway. Seatbelts were now fitted in cars as standard. The MOT started up in 1960.

In the 1950s, smoking was still good for you – it was sexy and the height of cool. Doctors were paid to promote the benefits of ingesting toxins and tobacco companies spent millions getting new recruits on board as young as possible. Camel vaunted that more doctors smoke Camels than any other brand. In '50s Britain, 80 per cent of adults, and not a few children, were hooked, some dying early as a consequence years later. However, in 1951, Sir Richard Doll proved the link between smoking and cancers and things started to change, slowly.

On the wider stage, Britain's empire began, bit by bit, to slip away into independence. There was trouble in Korea, Malaya, Kenya, Cyprus and Suez,

In July 2014, a York primary school celebrated its sixtieth anniversary, with pupils and staff dressing up in '50s style for a *Grease* flashmob dance. Burton Green Primary School, formerly Burdyke Infant School, was opened in 1954. Most of the school's 200 pupils and most members of staff dressed in '50s clothing to stage a performance in the playground of dances to a medley of music from the hit musical, to the surprise of parents who had no idea of what was being secretly planned. (Picture reproduced courtesy of *The Press*, York, www.thepress.co.uk)

which demanded the attentions of British politicians and troops while a phoney third world war, the Cold War, began to preoccupy and dictate British military deployment, diplomacy, foreign policy and nuclear arms development. The British Army on the Rhine formed the front line and faced the very real Soviet threat posed by sixty Russian divisions stationed and lined up opposite them in East Germany. We were the third power to get the atomic bomb in 1952 and the hydrogen bomb in 1957. The world was still a dangerous place in the 1950s; the peace we enjoyed was nothing if not fragile. In the 1950s, Britain lived under the frigid shadow of the Cold War and the bomb. She had to learn the hard way that she was no longer boss of the world – the ignominy that was Suez demonstrated that. National Service was a fact of life for most eighteen-year-old men. From 1948 to 1960 each year, some 160,000 donned a uniform and left home for two years, while the campaign for Nuclear Disarmament did its best to apply a modicum of reason.

So how far was the city of York affected by all of this – the trends, progress and the '50s phenomena? How far did the decade change the city? The following chapters describe and depict those changes.

1950S YORK

York's population during the 1950s was growing. In 1941, it stood at 123,227, up 9.6 per cent from 1931. In 1951, there were 135,093 people living here, also up 9.6 per cent from 1941, and in 1961 there were 144,585 of us – up 7 per cent in the ten years from 1951. In 1950, York covered 6,456 acres, rates were 18s 6d in the pound. While other towns and cities absorbed immigrant workers from the old empire, York has remained predominantly white and Anglo-Saxon, and that is how it was throughout the 1950s. Age and sex were close to the national average, although there was a slow but inexorable rise in the elderly population.

York is very compact. The ratio of population to area is noticeably high compared to similar cities like Chester, Winchester, Exeter and Lancaster. Within and immediately outside the walls, the housing is characterised by high density, nineteenth-century dwellings. Further afield, twentieth-century houses built in open estates dominate from the '30s and after the war in the '50s.

Urban development in 1950s York was, as in other places, dictated by an advisory plan published in 1948 under the statutory obligation of the 1947 Town and Country Planning Act to survey the physical, economic and social conditions of their areas. This entailed the establishment of traffic and employment zones, the latter leading to many old York businesses moving to the outskirts. Traffic was another matter, though, with the narrow, medieval streets and precious architecture a major impediment to any development that might compromise or wreck the city's unique heritage. York was the bridgehead over the Ouse and attracted endless streams of heavy traffic from the port of Hull and the industrial towns of West Yorkshire, from the industrial North East to the cities of the Midlands. Seaside traffic from the west added to the problems as it crawled through York en route to Whitby, Scarborough and Filey.

York's survey took place between 1949 and 1951 and the Development Plan (taking us up to 1971) was submitted in early 1952 to the Minister of Housing and Local Government to be approved, with modifications, in 1956. How was the plan going to solve York's mostly unique problems? Because road and street widening was not an option, an inner ring road (or sections of an inner ring road) set back from the walls was found to be vital to divert traffic from the congested centre. This meant more bridges over the Ouse. Of all traffic entering the city, 42 per cent was through traffic with no business in York. This had to be channelled away from the centre. There was also the acknowledgement that up to 15,000 bicycles were

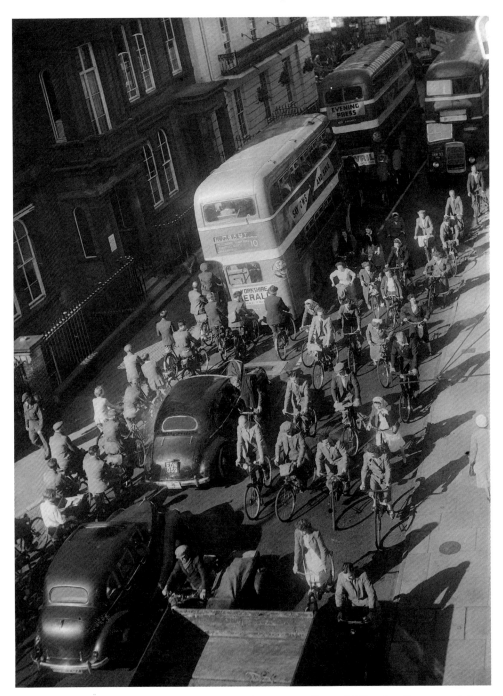

A busy day in Museum Street with streams of motor traffic and bikes heading to and from Lendal Bridge. York's bridges have always been a nightmare, acting as a powerful magnet for all manner of traffic, much of it through traffic in the 1950s. As recently as 2014, the council made a lame and bungling attempt to solve the problem by closing Lendal Bridge and fining trespassers. The fines were later repaid. (Picture reproduced courtesy of *The Press*, York, www.thepress.co.uk)

pedalled through the city centre every day and provided a further complicating factor. The need for an outer ring road was accepted but regarded as unlikely to materialise as it would, the same as today, not have a great impact on city centre congestion. The two necessary bridges over the Ouse were planned and Clifton Bridge was completed in the '60s. For housing, much of the congestion within the walls would be cleared and replaced with lower density accommodation.

After the war, it was government policy to seduce local authorities with generous subsidies to build high into the sky in order to replace bombed-out or derelict properties and so ease the housing shortage. York's low-level skyscape, quite unique in a city of its size, is the legacy of one Labour Alderman Bill Burke, Chairman of the Housing Committte. Burke famously retorted to an offer of subsidies made at a council meeting: 'Over my dead body will we have bloody tower blocks in York'. Burke is up there with Etty, Evelyn and Sir Walter Scott as a valiant and jealous preserver of the city's heritage and character, in the face of stupid perpetrators of civic vandalism who seem to blight and darken every age. Just note the Stonebow. As a footnote, it is worth pointing out that Burke was not all heart. When Lord Esher came to the city in 1967 (surreptitiously to avoid the press and a hostile council), Burke told him bluntly, 'We don't like consultants here.'

Nationalisation of the utilities and hospitals in the previous decade removed a number of lucrative revenue streams for the corporation, although the waterworks were still in private hands in 1959. Other businesses now preoccupied the commercial activities of the corporation such as the markets, local transport, parking and the river navigations. The cattle market still flourished with a high point of stock of 170,000 in 1957/58 passing through it. Bus passengers increased significantly with around 31,000,000 getting on and off York's buses every year throughout the decade. Both the Ouse and Foss Navigations recovered from their depression during the war, but after 1953 started to lose money as traffic declined. 'Education, education, education' became the priority along with, not unusually, public health and welfare, the maintenance of streets and buildings, and policing.

Politically, Labour had assumed control of the council for the first time in 1945, then lost and regained it on a number of occasions. At the end of the decade, the Conservatives held office. Nationally, York's parliamentary seat was held by the Conservatives from 1939–45 and from 1950–59. The years 1945–50 saw Labour in office. In 1945, the results were as follows: John Corlett (Lab) 22,021, Lord Irwin (Con) 17,949 and G. H. Keighley Bell (Lib) 4,208. York Communist Party hovered in the background still.

Economically, confectionery, through Rowntree, Terry and Craven, and the railway works remained the leading industries and employers. Around 7,000 were employed in transport, with 4,800 of them on the railways out of a total male working population of around 36,000 in 1951. Feeding the housing building programmes were 2,800 craftsmen and labourers. The female working population was around 18,000, from which 5,100 worked in confectionery, around 3,000 worked in shops and around 2,600 worked in professional services.

Soon after the war, tourism was identified and enthusiastically nurtured as the city's new cash cow. For example, attendances at the Castle Museum increased threefold from 110,000 in 1946 to 352,000 in 1957. A tourist information centre and a voluntary guide service were set up in 1951. York races went from strength to strength, while the Knavesmire hosted prestigious events such as the Royal Agricultural Show in 1948 and the Northern Command Tattoo in 1955. The British Association met for the sixth time in York in 1959. There were no fewer than three York Festivals of the Arts. The first was in 1951 and was a hugely successful satellite event in the Festival of Britain. The director of York City Art Gallery, Hans Hess, remarked that 'York found its soul'. The others took place in 1954 and 1957. The undisputed star of the festivals were performances of the York Mystery Plays, dramatically and atmospherically set in the ruins of St Mary's abbey. There were also concerts, exhibitions, lectures and a Georgian costume ball in the refurbished and restored Assembly Rooms at the Festival Club in 1951. As a food office, the magnificent pillars here had been painted orange. Sir John Barbirolli conducted Walton's 'Balshazza's Feast' in the minster. The Civic Trust gave its blessing to York's second city centre chip shop.

1954 saw the *Yorkshire Gazette* amalgamate with the *Yorkshire Herald*. On 25 June 1954, the first edition of the combined *Yorkshire Herald* and *Yorkshire Gazette* was published as the *Yorkshire Gazette & Herald*. Westminster Press, owners of York & County Press, bought the *Yorkshire Evening Press* and the *Gazette & Herald* from Kemsley Newspapers in 1953.

The York Civic Trust achieved much of enduring value in its first five years as doughty preserver of York's heritage and, indeed, helped to make the city something more than just an 'outdoor extension of the Castle Museum' – always

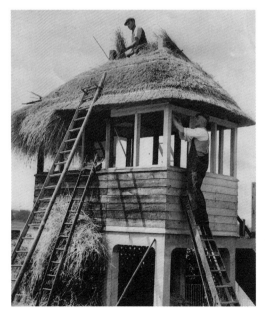

The steward's box at the Knavesmire receiving some finishing touches before a meeting in August 1955. The thatcher was Mr O. Eccles. (Picture reproduced courtesy of *The Press*, York, www.thepress.co.uk)

a danger. Its work in the 1950s is still, of course, being enjoyed today. Among its prodigious and long-lasting achievements in the years 1950–55 are: obtaining a long lease for St Anthony's Hall, into which the Institute of Historical Research, the Borthwick, was installed; saving the redundant St John's church on Ouse Bridge from demolition and installing the York Institute of Architectural Studies there; gifting an Adam's chimney piece to the Mansion House and adding to the silver; reviving the art gallery with pictures and drawings, including two Ettys; six bronze plaques marking places of historical interest; outdoor oak seats; historical maps for fifty or so schools and work to keep the National Railway Museum in York. In 1955, the York Academic Trust was hived off as a separate institution. The significance of much of this work is that it brought York ever closer to finally becoming a university city and ending one of the anomalies of the modern age. The art gallery had been transformed from something of 'a quite insignificant backwater' to a thriving and vibrant repository for some of the nation's very important art; the renaissance continues in 2015 with the completion of another major refurbishment.

In 1956, John Smith's Tadcaster brewery revealed plans to demolish the unique and quirky delapidated Dutch House in Ogleforth; the Civic Trust saved it and restored it. In 1957, the cobbles on King's Staith were restored and with them the sensation of a burgeoning café society on the riverside. In 1958, the trust purchased Heslington Hall with financial support from the Joseph Rowntree Memorial Trust, thus presciently obtaining a nucleus for what was hopefully going to be the University of York.

In January 1952, after thirty-one years, the York Arts Society moved into its first headquarters in the newly restored Marygate Tower on Bootham. Coincidentally, the tower was, until 1644, a repository for the voluminous records relating to all religious houses north of the Trent, which were under the aegis of the King's Council in the North.

York is one of the few British cities that is blessed with authoritative, extensive and detailed research on its social life and activity. Benjamin Seebohm Rowntree (1871–1954) first reported on York's social situation in 1899, inspired and stimulated by the research of his father Joseph Rowntree in York, and of Charles Booth in London. One of the first statistical studies ever conducted, his comprehensive, no stone unturned survey into the living conditions of the York poor involved investigators visiting almost every working-class home – in other words, 11,560 families or 46,754 individuals. Rowntree's findings were published in his 1901 groundbreaking, landmark study, *Poverty: A Study of Town Life* – a book which helped lay the foundations for the modern welfare state and established the poverty bar as a credible benchmark. His description of Hungate then gives a flavour of this exhaustive work and neatly summarises the situation. He describes the area as typical of urban slum life, while only too mindful that by no means was everyone there so feckless: 'reckless expenditure of money as soon as obtained, with the aggravated want at other times; the rowdy Saturday night,

the Monday morning pilgrimage to the pawn shop ... the despair of so many social workers.'

Two further York studies followed. Seebohm's third York poverty survey was published in 1951 as *Poverty and the Welfare State* with George Russell Lavers. The subtitle was *A Third Social Survey of York Dealing only with Economic Questions*. It concluded that poverty was now considerably less of a problem, despite remaining pockets, mainly among the elderly. Welfare benefits, though, could eradicate much of this. Primary poverty afflicted 846 families and was down to 2.77 per cent of the working population, and 1.66 per cent of the total population compared with 31.1 per cent and 17.7 per cent in 1936. Of these poor people, 68 per cent were in poverty because they were elderly. Sickness accounted for a further 21 per cent. Significantly, the focus on old age was to make elderliness a major focus in subsequent poverty studies.

It is to his 1951 work with G. R. Lavers that we must turn to for a remarkable and unique insight into early 1950s York life. That study is called *English Life and Leisure: A Social Study*. The interviews, often somewhat impressionistic and judgmental, are nothing if not frank. They, nevertheless, shine fascinating light into an obscure corner of life at the time, as these random selections show:

Mrs. W. is distrustful of her fellow humans for most of them look down on her and show it. She might be any age between 40 and 55, but says she is 39. She is enormously fat, to an extent that defies description, and though she lives in a large, well-fitted council house in a large town, she is a complete slattern. She goes about with her clothes unfastened, bare feet thrust into muddy carpet slippers, long black hair uncombed, dirty hands and dirty face. Two men live with her, to one of whom she is married, and her children are divided between them. She is now pregnant again and it is astonishing that either of the men both decent working-class types could copulate with such a monstrous creature. Mrs. W. herself had her first child at the age of 17 out of wedlock. The child, a girl, in turn had her first child at the age of 17 out of wedlock. Mrs. W. says rather helplessly that she supposes any day now the second daughter, will probably come home and say she is 'in trouble.' Because the neighbours openly scowl at Mrs. W. ('She lets down the neighbourhood') she seldom goes out except for shopping. She is friendly once she gets over her suspicion, and the home is clean although untidy. Mrs. W. is a good cook and a devoted though not very prudent mother. She drinks spirits heavily when she can afford them (in this menage a trois there is plenty of money), and smokes heavily. She never goes to church because, she says, when she was a kid and first 'in trouble' and needed a bit of help, the church people were the first to turn their noses up at her. Now she doesn't want anything to do with them.

On the other hand,

Mrs. D. is a young housewife of 26. Her husband is an architect. They are very much in love and are anxious to get a house of their own (they are now in a furnished flat) because they want to start a family. They hope to have three children. Mrs. D. is a very gentle

person who would do anything for anyone. She has not been a regular churchgoer but was married in church and has started going occasionally. As far as can be told, her life has no vice or unpleasantness of any kind, and a church could hardly make her better! She is a teetotaler and non-smoker. Is of course innocent sexually, and does not gamble. She likes the radio, cinema and theatre, but her main recreation is looking after her husband.

And,

Mr. X. is a clerk in a Government office. Aged 39, widower, no children. Keeps aged mother and unmarried sister. He professes to be an Anglo-Catholic. Earns 8 per week. Smokes fairly heavily (30 cigarettes per day, but is trying to reduce), and drinks beer, and occasionally whisky. Does not bet. Interested in politics but takes no active part. Occasionally picks up a prostitute and wishes he could afford a regular mistress. Reads several newspapers, both left- and right-wing, and is fairly well informed about current events. Reads biographies and travel books. Not interested in the cinema, but enjoys a good play. Is worried about the state of the nation and would accept a measure of dictatorship if only a national leader would appear. Oddly enough he takes days off from his work fairly frequently by taking advantage of a rule that he can be 'sick' one day without a doctor's certificate and without forfeiting pay. Was formerly a keen footballer but is now too old. Does not enjoy watching games. Gardens to grow vegetables. Not much interested beyond utilitarian aspect.

We hear also of Mr H., twenty-two-year-old son of a publican who 'smokes heavily and considers himself something of a Don Juan, has no discernible interests except gambling, women and drink … a nasty piece of work'; Mr C. 'is mildly homosexual and this had obviously sapped his moral fibre'; Mrs Z., a colonial widow who 'probably does not stop talking long enough to enable a man to make improper advances', and Mr P. whose 'two interests are games and women – cricket in summer, football in winter, and copulation all the year round … not a churchgoer'.

Other chapters follow on 'Commercialized Gambling' and 'Drink' where we learn that 'the total personal expenditure on alcoholic beverages in 1948 was £762 million, compared with 285 million in 1938 … the nation was spending as follows:

(a) One-quarter more on alcohol than the total spent on rent, rates and water charges
(b) More than five and a half times as much on alcohol as on books of all kinds, and on newspapers and magazines
(c) 7s on alcohol for every £ spent on food

Then there were chapters titled 'Smoking', 'Sexual Promiscuity', 'How Honest is Britain?', 'The Cinema', 'The Stage', 'Broadcasting', 'Dancing', 'Reading Habits', 'Adult Education' and 'Religion'. Gambling was 'Public Enemy No. 1', to complete the fascinating, if worrying, picture.

Unenforced leisure, both as a concept and as an elective social activity, was new – hitherto it had been an obligatory and unavoidable by-product of unemployment. Shorter working hours and longer statutory holidays (pioneered to some degree, ironically, by the Rowntree's in York) meant that the working man and woman now had time on their hands to do with as they wished.

Research for *English Life and Leisure* began in 1947, fuelled by the 'inadequacy of the means provided for the satisfactory recreation of the citizens of York' – there was, for instance, only two youth clubs in the city, one for girls and one for boys, and to establish what would be required to make that provision. Case histories of 975 York interviewees, 'who have revealed their philosophy of life without realizing they were doing so', included twelve girls from 'a Borstal Institution'. Twenty case studies from people under the age of twenty and 200 over the age of twenty make up the first chapter.

In a letter to his granddaughter Greta von Kulnett, in July 1951, Seebohm confessed to 'excitement' at the 'stir' his book had 'created in England'. One newspaper had described it as the equivalent of 'social dynamite'. The first print run of 7,500 copies sold out within a few weeks, as did a 2,000 copy reprint. Sales of *English Life and Leisure* exceeded 10,000 by the end of the year. 'Despite the bitter criticism it evoked, both from clerical professionals and lay experts ... [it] survived to become an enduring classic of modern British social science'. According to Seebohm it was the only book he published that saw a profit.

Seebohm Rowntree died on 7 October 1954. His unstinting and tireless work on the conditions of the poor people of York and on social welfare reform made York, and indeed the country, a better place. He made a substantial contribution to the final form of the National Health Service and his work influenced and informed the Old Age Pensions Act of 1908 and the National Insurance Act of 1911. His 1901 *Poverty: A Study of Town Life* remains a classic and is one of our most influential pieces of research ever published.

In January 1952, the York Cooperative Society had the following on sale: shirts at 15s 11d, sports trousers at 25s, (itchy) tweed knickers at 7s 11d and smart tweed suits for school at 35s 6d. Cussins & Light in King's Square urged us to 'call for a demonstration of a Television Receiver – the "Modern Magic Box" – HP terms available'. The ABC was showing Stanley Holloway in *Lady Godiva Rides Again*, while the Rialto in Clifton had *Red Mountain* starring Alan Ladd.

The unprecedented reliance on women to fulfil roles and do jobs hitherto exclusive to men in the workplace during the First and Second World Wars led to a newfound independence and social activity. This is reflected in the number of clubs and associations they formed and enrolled in during the 1950s, although it was virtually all middle class and professional. They included the Inner Wheel Club (the equivalent to the men's Rotary Club), York Women's Luncheon Club, Guild of Railway Women, Electrical Association of Women, York Women's Liberal Club and the York Female Friendly Society. Women's Institute branches continued to thrive.

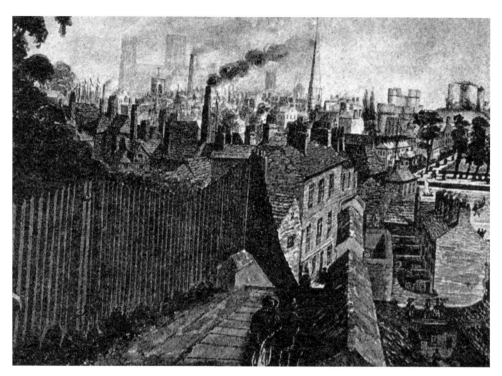

A typical scene of inner-city poverty in York at the end of the nineteenth century. The years from 1930 to 1960 witnessed a slum clearance programme, although this was interrupted by the Luftwaffe's indiscriminate bombing during the Second World War.

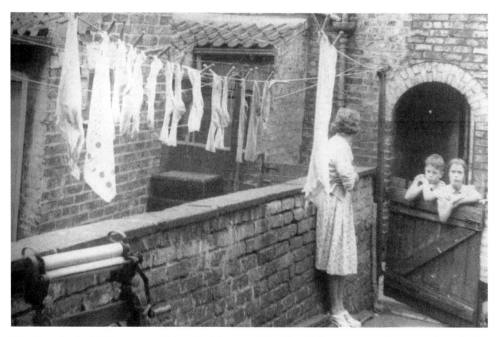

Washing day in 1950s was traditionally Monday. This Health Department photograph probably shows George Street in the Walmgate district of the city. Damp, overcrowding and insanitary toilet facilities were still the norm for some people.

CLEARING UP – SLUMS AND
THE LUFTWAFFE

Before the Second World War, York Corporation had embarked on a challenging programme of slum clearance and housebuilding in the city. However, the war interrupted all that and some projects were shelved. Even in 1945, for example, the plan for municipal offices on a single site to accommodate scattered corporation departments – foundations had gone down in the castle precincts by 1939 but work was cancelled after the war. Acomb, Dringhouses, Middlethorpe and the north side of York had been brought within the city boundaries and saw new building replacing slums in 1934 and 1939. An area to the south-west of the city was added in 1957. During the war, 9,500 or so houses had been obliterated or damaged and eighty-seven people were killed, mostly during the Baedeker raid of April 1942, when notable buildings such as the Guildhall and St Martin's church in Coney Street were gutted, and the Bar Convent and railway station were badly damaged. Existing industrial firms such as Rowntree (as County Industries Ltd) and Cooke, Troughton & Simms were pressed into war production producing armaments or military equipment, only resuming normal activity in 1945.

The unfortunate coincidence of the increase in the city's population to 105,336 in 1951, the postponement of building during the war and the bomb-damaged stock gave rise to a serious housing shortage in the years after the war. Slum clearance and rebuilding were rushed forward, especially in The Groves and Walmgate area, but this was still incomplete in 1959. The Corporation had to act and so, between April 1945 and December 1958, over 4,600 council houses plus around 450 prefabs and 2,000 or so private houses were built in the city. Flats went up on the land between the Red Tower and Walmgate. There was, in addition to this, significant private building in areas on the periphery such as Clifton Without, Rawcliffe, Huntington, Fulford and the Poppletons. A further extension of the city boundary to the north was considered in 1959. There was also building in Haxby and Wigginton, which gradually changed from being villages full of farms to dormitory settlements serving York.

Prefabricated houses were an inspired and much sought after part-remedy to the housing shortage and the scarcity of building materials. Built swiftly

and with low labour cost and time, prefabrications were to a standard template with the components constructed in factories. They boasted an attractive interior design with a good-sized sitting room complete with coal fire, and a back boiler that provided hot water and, amazingly, central heating. Modern bathrooms featured heated towel rails and the kitchens had built-in units and refrigerators – a flat pack microcosm of the future.

Post-war timber shortages and rationing of wood meant that furnishing a new house was difficult. Newly married couples were given priority, but were restricted to British-made Utility furniture under the Utility Furniture Scheme introduced in 1942 and closed in 1952. In 1953, the prestigious and much more stylish G Plan range of furniture was introduced. This had the financial advantage that it could be bought piece-by-piece over a number of years.

To replace the slums cleared in 1939 in Walmgate, flats were built while the Hungate area was developed and a new road, The Stonebow, was laid down, graced by some of the city's bleakest and most wretched architecture, which included the aptly termed Brutalist (from the French *béton brut*, or 'raw concrete') building that was the telephone exchange.

The Stonebow, a blot on the landscape, successfully blotted out any view of St Saviourgate and its grand places of worship. Its name derives from the medieval street name, Le Stainbowe.

Essentially, though, the city's streets were allowed to continue much as they were in the eighteenth century and before. The only real changes in the '50s were the modernisation of shop fronts and the erection of large stores with their anodyne, plate glass windowed façades. Corporate policy seems to have been to make the windows themselves as featureless as possible (relying on the goods visible inside them for impact) and the same as next door's and identical to the windows in any other branches in the UK, regardless of where they were or their local setting. One exception was Spurriergate, where a site was cleared in 1959 for new shops. In the same year, the riverside gardens opposite the Guildhall were laid out, the land donated by Rowntree's whose Tanner's Moat factory building had stood on the site.

The 1950s explosion in car ownership was always going to have serious consequences in a city like York with its horse-friendly, eighteenth-century streets and circuitous road systems. The one-way traffic system instigated during the war and the necessarily draconian parking restrictions were nothing more than a finger in York's dyke. Astonishingly, the inner ring road, had it gone ahead at the end of the decade, would have meant the wholesale, wanton destruction of some of York's finest housing stock. It was all perilously close – things had moved on to the degree that householders were told that the bulldozers and wrecking balls were on the way.

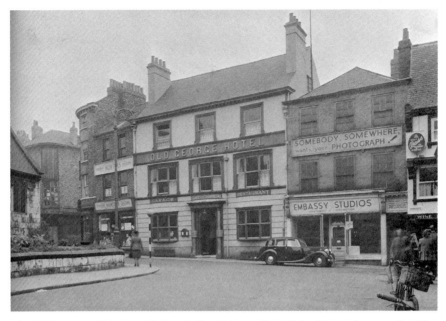

The Old George from 1770 just before it was demolished to make way for The Stonebow in 1955. Note the offer of passport photographs at the photograph studio next door – also demolished. (Picture reproduced courtesy of *The Press*, York, www.thepress.co.uk)

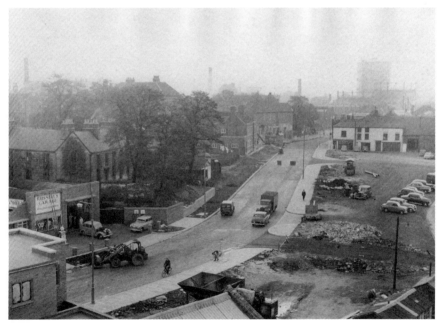

A 1955 shot of the final touches being added to The Stonebow, built on the wasteland left by the mid-1930s demolition of Hungate slums. Russell's garage is on the left, founded in 1945 and remaining there for some forty years. (Picture reproduced courtesy of *The Press*, York, www.thepress.co.uk)

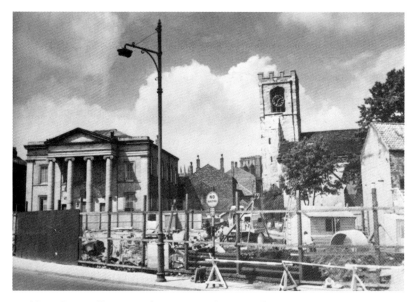

Building the repellent Stonebow was architecturally a sad time for York as the Brutalist construction later obscured completely the view of the three places of worship we can still see in this photograph. *Left to right*: Centenary chapel of 1840 (Central Methodist church), York Minster, St Saviour's church – now the wonderful Archaeological Resource Centre. (Picture reproduced courtesy of *The Press*, York, www.thepress.co.uk)

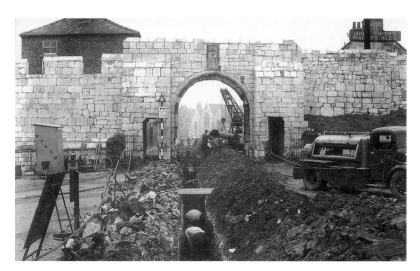

St George's Bar, now known as Fishergate Bar, gateway to Selby. This shows utilities pipe laying in progress in the 1950s. The John Smith's Phoenix Inn brewery can be seen to the right in Long Close Lane. The building on the left was Falconer's the furnishers. The bar was blocked in 1489 after a revolt by rebels over punitive taxation; the fire damage is still visible. It was reopened in 1827. In Elizabethan times, it was a prison for rascals and lunatics. St George's Roman Catholic church can be seen in the distance, built in 1850 to meet the spiritual demand from Irish immigrants. (Picture reproduced courtesy of *The Press*, York, www.thepress.co.uk)

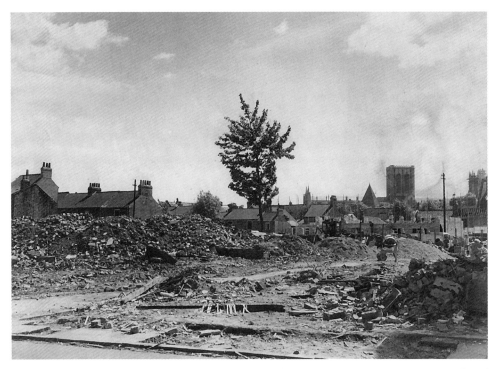

Devastation in Lowther Street, with slum clearance well under way in 1959. (Picture reproduced courtesy of *The Press*, York, www.thepress.co.uk)

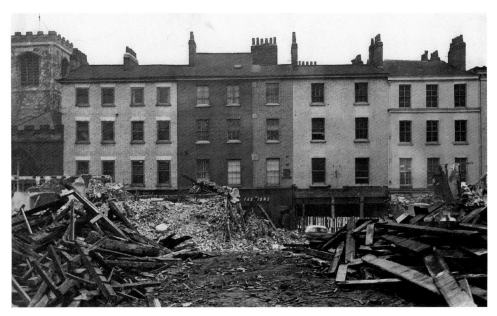

Clearing the way for a new Spurriergate in March 1959. The short street underwent further development in the 2000s. St Michael's church is on the left, today usefully employed as a café, restaurant and shop in the splendid surroundings of the fine old church – the Spurriergate Centre. (Picture reproduced courtesy of *The Press*, York, www.thepress.co.uk)

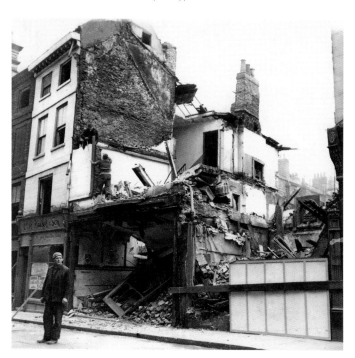

Right: Knocking down to build up in Spurriergate in 1959. (Picture reproduced courtesy of *The Press*, York, www.thepress.co.uk)

Below: Laying down the river walk on King's Staith in 1958; Boyes and Yates' Wine Lodge (champagne on draught!) beyond Ouse Bridge. (Picture reproduced courtesy of *The Press*, York, www.thepress.co.uk)

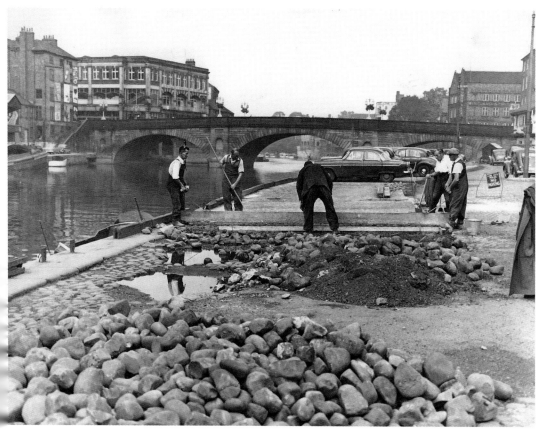

THE FESTIVAL OF YORK, 1951

One of the hopes and aspirations for the festival was that it would leave a legacy of civic pride in local communities. Buildings such as St George's Hall, Liverpool, and Manchester's Free Trade Hall were restored while the South Bank's Festival Hall was a showpiece of new community architecture. Lansbury Estate at Poplar, the Speke Estate in Liverpool and Festival Flats in York were a few of the estates thrown open to the public as examples of 'Live Architecture', showcasing new ideas in construction, town planning and community living. Bomb sites, open spaces, gardens and war memorials were enthusiastically tidied up. York indeed was the major provincial festival centre in the north, its nearest neighbour being Liverpool. The city did much to live up to and enforce the mission statement of the festival – to 'challenge the sloughs of the present … [and project] a shaft of confidence … against the future'.

The national architectural competition involved the building of new flats on Paragon Street, known as the Festival Flats. Unremarkable as they may seem by today's standards, the contemporary press celebrated them as 'outstanding in design' and 'a modern architectural highlight'. Over 1,300 visitors went to have a look around inside.

Undoubtedly, though, the star of the show was the long-awaited performance of the Mystery Plays. *York Evening Press* announces the full programme on 16 July 1949:

> Plans for outstanding York Festival, York's part will be the most outstanding of all the 12 provincial cities playing their part in the international 'attract the tourists' campaign. Provisional plans for the festival included music in York Minster, sixteenth- and seventeenth-century music in the Merchant Adventurer's Hall, historical pageant in Museum Gardens, a world premier of a new play at the Theatre Royal, art masterpieces at the Art Gallery, dancing afloat the River Ouse, a military tattoo at Knavesmire, city floodlighting, a firework display, a Yorkshire Gala at Bootham, band concerts in the parks, an exhibition of transport at the station, a Georgian Ball in the Assembly Rooms, and an architectural competition for blocks of flats in Fishergate/Paragon Street, and Castlegate.

The 'historical pageant' was, of course, the Mystery Plays, performed on a fixed stage in the Museum Gardens – it was not until 1954 that a wagon play, *The*

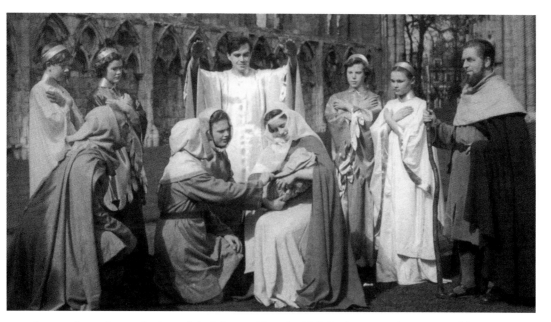

A scene from the production of the Mystery Plays in 1951 in the ruins of St Mary's abbey. Two Mount pupils, Mary Ure and Judith Dench, were in the cast as the Virgin Mary and an angel respectively.

Flood, toured the streets. The 1951 production was the most popular Festival of Britain event in the country, with over 26,000 people seeing the plays. The word 'mystery' in this context means a 'trade' or 'craft' in medieval English. It is also, of course, a religious truth or rite; the medieval plays were traditionally sponsored by the city's craft guilds. Nowadays, the medieval Corpus Christi plays are produced every four years, most recently in 2012, by the York Guilds and Companies. The Creation to the Last Judgement are paraded through the streets on pageant wagons as actors perform selections from the forty-eight high points of Christian history at twelve playing stations designated by the city banners, with one guild taking responsibility for one episode. The sole surviving manuscript of the York plays, from around 1465, is in the British Library. An interim performance took place in York in 2014.

Back in 1949 the event was announced with alacrity: the *Northern Echo* of 29 April 1949 proclaimed 'York plans for biggest event of the century', while the *Yorkshire Evening Post* on 24 December 1949, told us,

> York plans a festival of Pageantry and Pomp - £30,000 of plays and concerts... convinced that the most outstanding event of the fortnight will be the 15 performances of the cycle of religious plays... Special care is being taken to ensure that the costumes will be authentic in every detail ... hopes the actors will agree to change in their homes and make their way to the theatre in their costumes just as the players did in the 14th and 15th centuries. The part of Christ will be played by a professional actor, who will remain anonymous.

A scene from the 2014 performance in College Street.

In the following year, the *Yorkshire Post* on 26 May 1950, said 'York Medieval Plays [are] of world importance.' The *Yorkshire Gazette* in its review of 8 June 1951, published photographs of royalty, Prime Minister Clement Attlee and York politicians and their wives at the minster:

> The powerful appeal of the mystery plays: outstanding feature free from sophistication. After watching the opening performance of the York Cycle of Mystery Plays – publicly presented on Sunday night [3 June 1951] for the first time for nearly 400 years, to an audience which included the PM and Mrs Attlee, the civic heads, the city's MP and robed representatives of the craft guilds, with whom the Plays had their beginnings – it is not difficult to understand their powerful appeal to the original medieval audiences.

The *Yorkshire Post* chimed in on 18 June 1951: 'York's Festival Triumph – a fortnight of imperishable memories – question remains – will the Mystery Plays be allowed to return to the dust which covered them for four centuries?'

The Mystery Plays, and the York Festival generally, were clearly a resounding success for the city and for Britain. However, predictably, they did not go ahead without controversy. Prohibition still existed in England on the representation of God, so the name of the professional actor hired to play Jesus was kept a secret. Furthermore, the Dean of York banned the representation of the

Right: Eve tempted by Satan in the 1957 production. Sheila Barker was Eve and the devil was Gerald Morden.

Below: Guards in Shambles at the Festival of York. (Picture reproduced courtesy of *The Press*, York, www.thepress.co.uk)

giving of the Sacrament of the Last Supper. Jesus was played by one of the few professional actors in the production – Joseph O'Conor. Many of the other 300 were chosen from local amateur dramatic groups. The 1951 production was the start of something great and wonderful; the plays have been performed regularly ever since with performances in 1954 and 1957. Actors of the calibre of Mary Ure, Judi Dench and Christopher Timothy cut their teeth here. The brilliant and inspirational Hans Hess was curator at the York City Art Gallery from 1947 until 1954 when he took over as York Festival director, second only in reputation to the Edinburgh Festival.

Streets, Squares and Bridges

1955 was a big year for York's markets. It saw the start of a nine-year-long move from Parliament Street to Newgate. Parliament Street is still the venue, though, for frequent weekend local produce and continental markets. Originally, the market extended from Pavement to St Sampson's Square, five rows of stalls deep.

The '50s saw an extensive restoration programme for York's famous gateways, the Bars. Micklegate Bar was restored by the corporation in 1952/53, as was Monk Bar. Walmgate Bar (the only one to retain its barbican) was restored in 1959 – it still has its portcullis and an inner wooden door.

Cussins & Light was established in 1934, on the corner of King's Square and Goodramgate, to satisfy the increasing demand for radios and for radio rentals. Electric cookers, vacuum cleaners and washing machines were slowly increasing in popularity and these too became stock items. In 1951, the Holme Moss local BBC transmitter flickered into action causing an upsurge in television ownership and rentals in York. Cussins & Light were well positioned to service this demand, exploding as it did in good time for the televising of the Queen's coronation in 1953. Exhibitions were held at the Festival Restaurant (where Newgate market is today). The TV Studio at the shop in King's Square was converted into a mini cinema with rows of seats positioned in front of TV screens. Thousands were awed, and it was not unusual to sell thirty to forty sets on a Saturday afternoon. A 9-inch Bush TV cost £51 in 1953 with rental at 10s per week going down to 4s after four years. A 12-inch Murphy was 14s per week reducing to 5s. Hire purchase (HP) was also available.

Another famous Goodramgate business was John Saville & Sons, established in 1876. Until the 1950s it was mainly a pharmacy with a sideline in dental surgery and dental extraction. In the '50s, it focused on photographic equipment to cater for the growing popularity of cameras and photography as a hobby. In 1955, John Saville, the great grandson of the founder, produced a colour film of York with a commentary by Dr J. S. Purvis.

Two of the butchers in Goodramgate were Bowmans and Wrights. In the 1950s, Wrights bought the Bedern bakery and property on Aldwark and St Andrewgate where they built a factory. Here, animal slaughtering and pork pie and sausage roll production took place. Monday was slaughter day and black pudding was made.

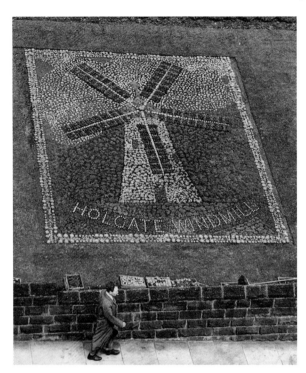

Station Road in June 1955 and winter 1956. The former shows a black-and-white image of the colourful floral depiction under the city walls of the Holgate Windmill, recently beautifully restored. The latter provides a Christmas card type photograph of a bus shelter opposite the station, the nearest York ever got to a bus station. (Pictures reproduced courtesy of *The Press*, York, www.thepress.co.uk)

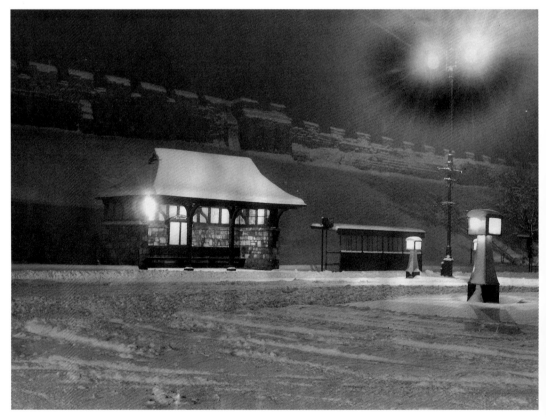

The corner of Gillygate and Lord Mayor's Walk in 1959. The houses in Lord Mayor's Walk have been demolished, victims of that age-old pretext – road widening. (Picture reproduced courtesy of *The Press*, York, www.thepress.co.uk)

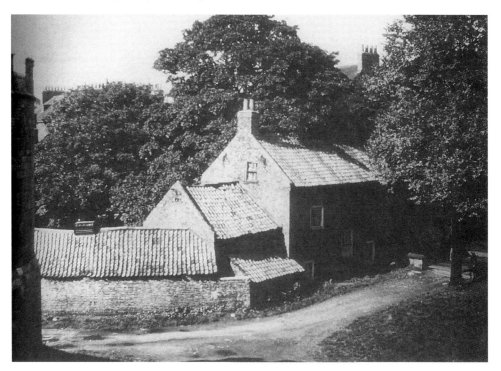

An amazing photograph of Reynold's Farm on the corner of Gillygate and Lord Mayor's Walk, 1957.

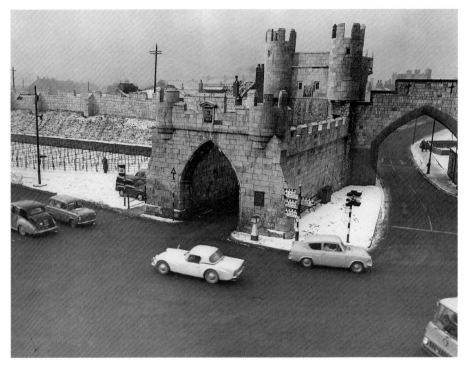

Free moving traffic around Walmgate Bar – a thing of the past.

A superb Stonegate Georgian shop frontage from 1829, which survived into the '50s and beyond. It is still there today, as is the impressive coat of arms, believed to be Dutch.

More '50s parking, this time outside the Castle Garage in Tower Street. (Picture reproduced courtesy of *The Press*, York, www.thepress.co.uk)

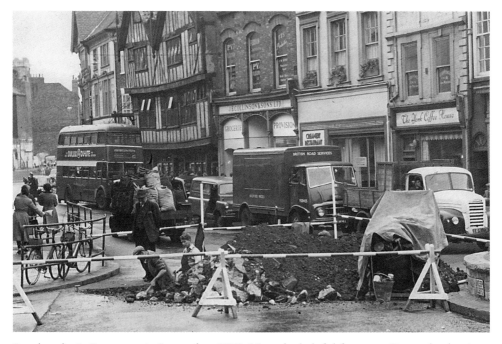

Roadworks in Pavement in September 1957. Note the helpful foreman. Domesday has it as 'Marketshyre' to signify the market that was held here for centuries; it was later renamed because it was a rare piece of paved ground in the city. Another market cross stood here, sadly demolished like the one in Thursday Market in a similar act of civic vandalism. A woman was sold here for 7s 6d. (Picture reproduced courtesy of *The Press*, York, www.thepress.co.uk)

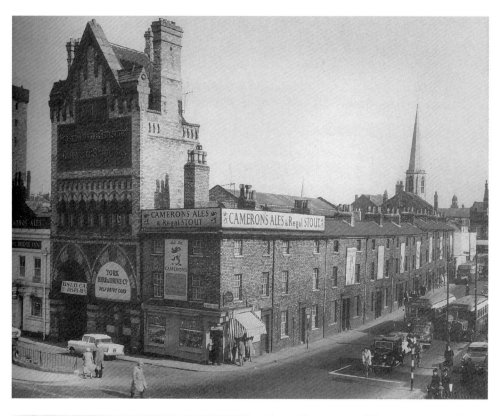

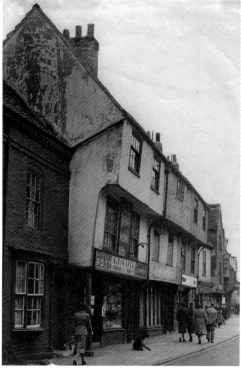

Above: The corner of Tanner's Moat and
Railway Street in the '50s with Botterill's
Repository for Horses still there intact.
Built in 1884 next to Lendal Bridge, it had
stalls for 200 horses, but was reduced in
height by a half in 1965 when it became a
car dealership. Patrick Nuttgens described
the original building as 'an exotic red and
yellow Byzantine building with ramps
inside, up which the horses were led to their
stalls – a kind of multi-story horse car park'.
It was frequently used by patrons of the
1868 Yorkshire Club for gentlemen (River
House) in from the country, just over Lendal
Bridge. Cameron's Ales were brewed in
West Hartlepool (now just Hartlepool) and
still are. The Lendal Bridge pub is now the
Maltings and Rowntree's offices were on
the left before the move to Haxby Road. The
terraces round the corner were demolished
to make way for Leedham's garage in 1962.
(Picture reproduced courtesy of *The Press*,
York, www.thepress.co.uk)

Left: Leaning shops in Micklegate, 1950.

One of the country's two surviving lantern windows, tragically obscured by bins today.

The street could also boast the popular Albany dance hall, Wilson's gun shop and Hunter & Smallpage. The Albany was noted for its sprung maple floor, the mirrors all around, the cinema seats in a dimly lit area at the back, and for fights. There was no bar, but dancers would go out to the nearby pubs during the intervals. A trapdoor on the stage led to a tunnel giving on to the street, allowing the performers access to the same hasty refreshments. Newitt's leather shop was at the top of the street catering for the cobblers in and around York. In between the wars Newitt's opened a sports department, specializing in football and cricket. There was expansion down Goodramgate and in St Andrewgate, buying up Wong Jock's Chinese laundry among others, to cater for the expanding trade in sports clothing (notably for golf), luggage and handbags. Exports to markets such as Poland started at the end of the decade.

Hunter & Smallpage was where you went for your post-war Utility Furniture, but their real business came later in the decade when more people had more money to spend on furnishing their houses in a much wider variety of styles and colours. At the Ideal Home Exhibition in 1955, the Hunter & Smallpage stand comprised a replica house – a show house. One of the features was a set of photoelectric cells that monitored the number of visitors and the consequent durability of their carpets.

There was also a drill hall in Goodramgate at the back of the Sandhill pub – the HQ of the York Territorials. One room was given over to a women's unit. It was here the women were trained as clerks, cooks, storewomen and drivers – the driving lessons and rifle training taking place at Strensall.

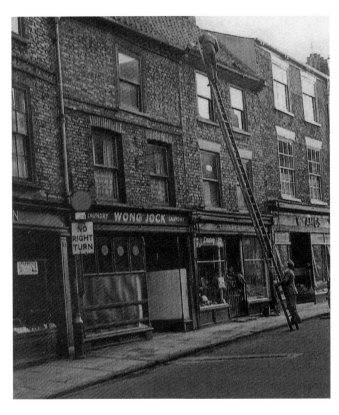

Wong Jock's laundry.

Colliergate was the home of Barnitt's, who saw considerable expansion in the '50s to service their growing sales of garden equipment, exciting new power tools and all manner of electrical equipment for the home and shed. There were also new departments selling soft furnishings and wallpapers. Barnitt's had become such a York institution that people said, 'If Barnitt's don't have it, you won't get it anywhere.' Bleasdales, the pharmaceutical manufacturer, were here too as well as a Dolls' Hospital. One of the city's first Chinese restaurants opened in Colliergate in the '50s, where Blackwell & Denton now is.

A snapshot of the type of place a city is can sometimes be obtained by a survey of some of the businesses that operated; York in the 1950s is no exception. We see that in 1950 there were four blouse specialists, two button manufacturers, thirteen corsetiers, six furriers, seventeen hatters and hosiers, one hide and skin merchant, four shirt makers, two sewing machine dealers including Singers Sewing Machine Co. in Coney Street, two silk mercers, thirty-four tailors including the two branches of the Fifty Shilling Tailors in Coney Street and Parliament Street, three umbrella makers and six woollen merchants all reflecting the fashions of the day and how clothes were produced – homemade was still very popular.

Our eating and shopping habits are revealed by the food shops that the city supported in 1950. There were no fewer than eighty-four butchers,

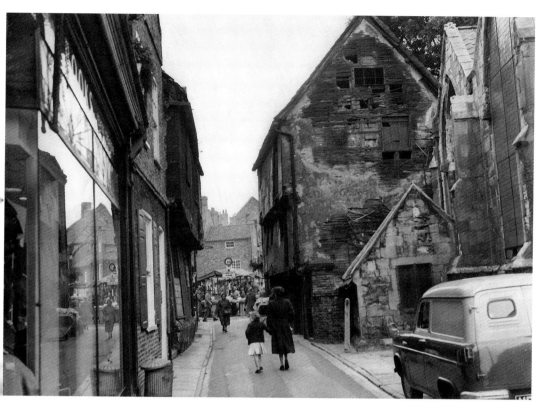

Above: Patrick Pool in August of the same year heading to the market. (Picture reproduced courtesy of *The Press*, York, www.thepress.co.uk)

Right: Minster Gates in 1959 when traffic came down Petergate and Stonegate. The shops were an antiques dealers, a travel agent (or tourist office) and an artist materials supplier. (Picture reproduced courtesy of *The Press*, York, www.thepress.co.uk)

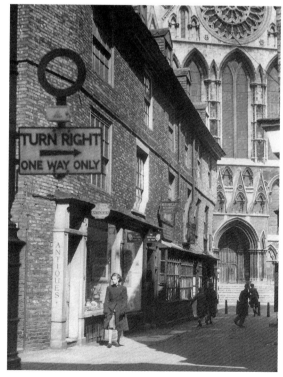

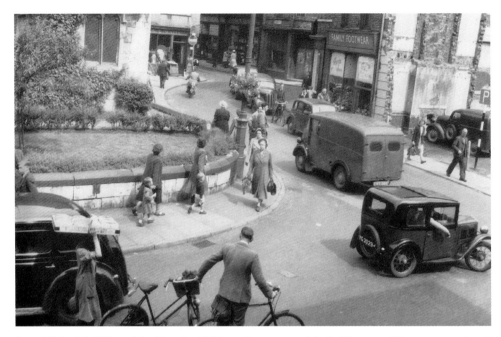

Busy Whip-Ma-Whop-Ma-Gate in 1956 at the corner with Colliergate. (Picture reproduced courtesy of *The Press*, York, www.thepress.co.uk)

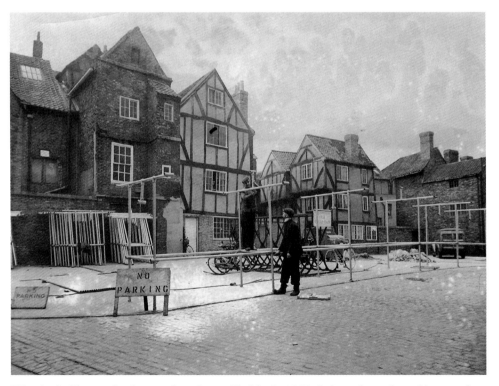

What looks like a rather bemused market stallholder in 1955. At least the cycle parking was free. (Picture reproduced courtesy of *The Press*, York, www.thepress.co.uk)

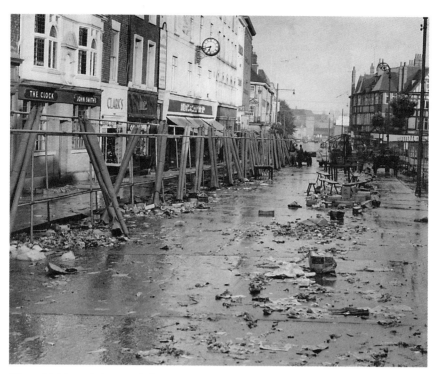

The rubbish and detritus left by the market in 1958 in Parliament Street, with the White Swan hotel on the right. (Picture reproduced courtesy of *The Press*, York, www.thepress.co.uk)

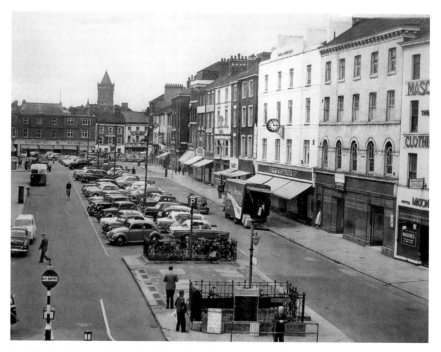

A tidier Parliament Street looking the other way towards St Sampson's Square.

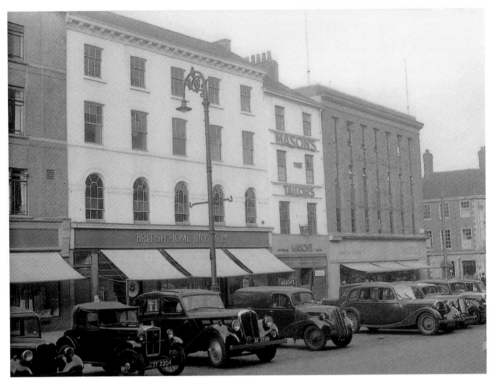

Parliament Street looking the other way.

one butchers' outfitters (C. A. Wilkman in Walmgate) and fifteen or so fishmongers and poulterers. There was also one chicory merchant, two horse and cattle slaughterers, three potato merchants, one salt merchant and two tripe dressers.

The rich variety of businesses on the city's increasingly cosmopolitan high streets is further exemplified and represented by such diverse concerns as the ten Chinese Laundries including Cheong, Fong, Foo, Wong, Kee, Lee, Shea and Song, the Pet's Nursing Home in Grape Lane, the Turkish bath in the same street, the two registry offices for servants and the razor and razor blade suppliers, Gillette Industries, in Minster Gates.

How we lit and warmed our houses, shops and offices is shown by the twelve chimney sweeps, forty-four coal merchants and seven firewood merchants. We get an idea of what we ate and drank socially from the four brewers and four chocolate makers. The brewers were Hope & Anchor Hungate, John J. Hunt, Spurriergate, Tadcaster Tower in Piccadilly and the Yorkshire Clubs Brewery in Marygate. Apart from the global concerns that were Rowntree's and Terry's, York had two other chocolate manufacturers – Dorothy Chocolates in Lead Mill Lane and Lazenby & Son on the Hull Road. Sweets were produced by Craven's.

York's national reputation for printing, publishing and bookselling in the 1950s is demonstrated by the paper merchant, the twenty-eight printers,

Calamity in Foss Islands Road with a lot of idle gawping going on.

The summer crush that was pedestrianised Stonegate with the Punch Bowl pub on the right and Raphael's hairdresser. Stonegate was pedestrianised in 1971. (Picture reproduced courtesy of *The Press*, York, www.thepress.co.uk)

the six sign, ticket and poster writers and the seven booksellers. The city's artistic tradition is evident too from the scenery and cut-out specialist, the fountain pen supplier (Bilborough's in Low Petergate), the two typewriter dealers (one of whom was Remington Rand in Minster Gates) and the two artists in stained glass.

How we spent our increasing leisure time is evidenced from the Central School of Dancing in High Ousegate, the twenty-two radio dealers, the three gramophone shops (including Banks, then in Stonegate), the solitary masseuse, York Mobile Cinema Service, the organ builder, the stamp shop in College Street and the ten music and singing teachers.

Despite all of this urbanisation, even in the '50s, agriculture and farming were never far away from the centre of York, as illustrated by the three gunsmiths and the five saddle and harness makers. The minster and other churches attracted the glass painter while other industries were served by the Yorkshire Ladder Co. on the Mount, the tinsmith, the whitesmith, the mattress maker, the three rubber and waterproofing goods manufacturers and the five surgical instrument and appliance makers. Our debt to the river trade is still being shown in the '50s by the rope and twine merchant, the sack contractor and

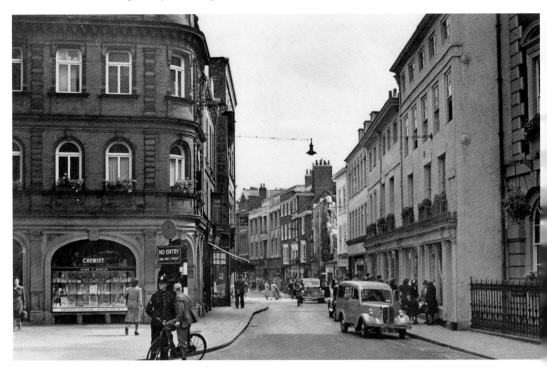

Coney Street from St Helen's Square with policeman directing the traffic. (Picture reproduced courtesy of *The Press*, York, www.thepress.co.uk)

The White Swan and the Regal cinema to the left, which closed in 1959. (Picture reproduced courtesy of *The Press*, York, www.thepress.co.uk)

British Railways 62744 steaming over Scarborough Bridge.

the marine store dealer and the buxom figurehead in Stonegate. The delightful statuettes of the Minerva at Minster Gates, the printer's devil in Stonegate and the native Indian in Petergate all indicate booksellers, printers and publishers, and a tobacconist at one time.

By the end of the decade, this menagerie of businesses had been joined on the city's streets by such concerns as a military outfitters, a honey merchant in College Street, a horse dentist, two stove enamellers and a watch strap and bracelet supplier – R. H. Seccombe in Clifford Street. The Chinese launderers had shrunk to five while the masseuses had increased to three.

Coney Street has long been an important thoroughfare and shopping street. In 1213, it was called 'Cuningstreta', from the Viking *konungra*, king, and *straet*, street. Famous businesses have included Leak & Thorp's, built on the site of the fourteenth-century Old George Inn, which was demolished in 1869. Archibald Ramsden's piano and organ shop moved there from St Sampson's Square. The Black Boy Chocolate Kabin, later sold to Maynard's, was next door to Leak & Thorp; the *York Press* was printed there as was the *Yorkshire Herald*.

Layerthorpe Bridge in May 1956 with commercial river traffic.

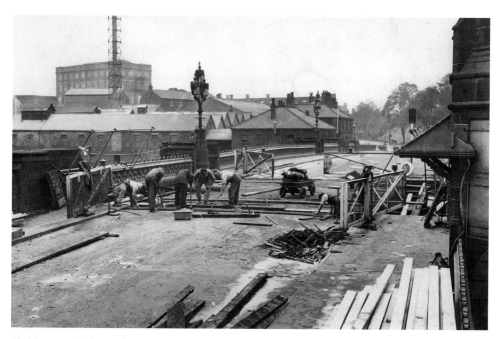

Skeldergate Bridge undergoing repairs in 1959. (Picture reproduced courtesy of *The Press*, York, www.thepress.co.uk)

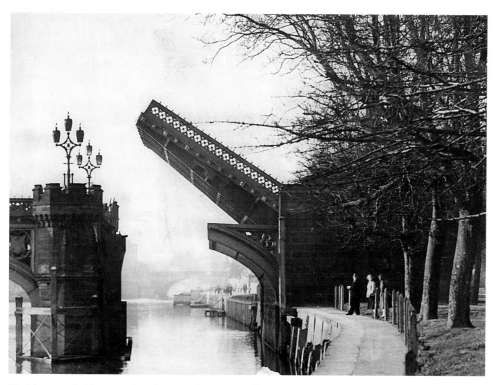

Skeldergate Bridge opening for repairs in March 1955. (Picture reproduced courtesy of *The Press*, York, www.thepress.co.uk)

Left: Busy Ouse Bridge in 1959 with Boyes in the background. (Picture reproduced courtesy of *The Press*, York, www.thepress.co.uk)

Below: Hats galore at Leak and Thorpe in 1950s Coney Street.

GETTING OUT IN YORK

Skating on the frozen lake at Rowntree Park in 1958. (Picture reproduced courtesy of *The Press*, York, www.thepress.co.uk)

The '50s were at the wrong end of the golden years of the cinema in York. At the beginning of the twentieth century, film shows could be seen in the Opera House, the Festival Concert Rooms, the Exhibition Buildings, Victoria Hall in Goodramgate, New Street Wesleyan chapel and in the Theatre Royal. The New Street chapel, after renouncing its use for worship in 1908, became first the Hippodrome, and then, in 1920, the Tower Cinema, which was still going in 1959. You could also see films at the City Palace, Fishergate, a venue for variety concerts from 1910. It was renamed the Rialto, but burned to the ground in 1935 and was replaced by the new Rialto on the same site. It was still going strong in 1959 with variety shows and concerts.

Some direction for the actor playing George Hudson in the 1951 York Festival production of *Sounding Brass*. (Picture reproduced courtesy of *The Press*, York, www.thepress.co.uk)

The Electric Theatre, Fossgate was opened in 1911 as the first purpose-built cinema in York. Entrance was through a door beneath the screen. It was known as the Scala from 1951 and closed in 1957, becoming a furniture shop, although the exterior is still beautifully preserved today. Locally it was known as the Flea Bin, and a visit meant a 'laugh and scratch'. Admission on Saturday afternoon was 4*d* or a clean jam jar – an early example of recycling.

Three more picture houses were established between 1911 and 1921: the Picture House, Coney Street, was opened in 1915 and converted to shops in 1955; The Grand in Clarence Street, opened as a cinema and ballroom in 1919 but converted to a roller skating rink and ballroom in 1958; and the St George's Hall, next to Fairfax House in Castlegate, was opened in 1921 and was still going in 1959. Four more were opened in the 1930s: the Regent, Acomb in 1934, the Odeon, Blossom Street, the Regal, Piccadilly, and the Clifton in 1937. The Regent closed in 1959, but the others survived the '50s. The Regent had the biggest screen in York and double seats on the back row for anyone not that interested in the main feature.

The Scala in 1957, shortly before closure. (Picture reproduced courtesy of *The Press*, York, www.thepress.co.uk)

The ten cinemas still showing in 1950s York were the Regal in Piccadilly, the Picture House in Coney Street, the Tower in New Street, the Electric Theatre in Fossgate, the Grand Picture House in Clarence Street, the Odeon in Blossom Street, the Rialto in Fishergate, St George's Hall Cinema in Castlegate, the Regent in Acomb until 1959 and the Clifton in Clifton – a massive choice.

Clubs were accessible to the well connected. As well as the usual Masons, Rotarians and Oddfellows there were branches of the Independent Order of Rachabites, the United Order of Druids, the Ancient Order of Foresters and the Royal Antediluvian Order of Buffaloes. The Melrose Club for the Blind catered for the visually impaired.

The York New Grand Opera House was opened in 1902 and was still going strong in the 1950s. It was built on the site of the corn exchange, King Street, by the owners of the opera house, Harrogate, offering 'varieties' to avoid direct competition with the Theatre Royal.

It was known then as the Opera House and Empire. From 1945 to 1956, F. J. Butterworth owned the Grand Opera House and stars such as Vera Lynn, Laurel and Hardy and Morecome and Wise trod the boards. The theatre was closed in 1956. In 1958, Shepherd of the Shambles bought it, and it became the SS Empire. The stage, lower boxes and raked stall floor were removed and replaced by a large flat floor suitable for roller-skating, dancing, bingo and wrestling, reflecting dramatically changing tastes and requirements in entertainment in the 1950s.

The Grand in Clarence Street after conversion in 1959. (Picture reproduced courtesy of *The Press*, York, www.thepress.co.uk)

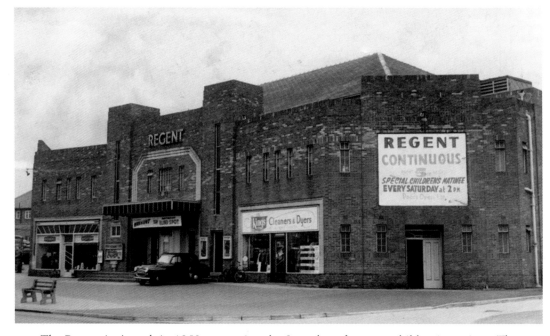

The Regent in Acomb in 1959 promoting the Saturday afternoon children's matinee. The main event was *Blind Spot*, a 1958 British film directed by Peter Maxwell and starring Robert MacKenzie, Delphi Lawrence, Gordon Jackson, John Le Mesurier and Michael Caine. (Picture reproduced courtesy of *The Press*, York, www.thepress.co.uk)

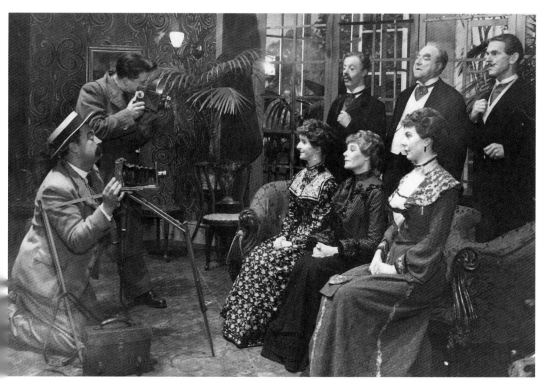

Right: The programme for the 1957 production of *The Desert Song* at the Theatre Royal by York Amateur Operatic and Dramatic Society.

Below: York Repertory Co. in 1955 in a production of *When We Are Married*. The *York Evening Press* photographer is behind the drunk photographer acting in the play (J. Barrie). (Picture reproduced courtesy of *The Press*, York, www.thepress.co.uk)

YORK AMATEUR OPERATIC AND DRAMATIC SOCIETY

THE DESERT SONG

THEATRE ROYAL YORK JANUARY 1957

Again in 1959 with John Tinn as the Japanese Soldier, James Beck on the right and Trevor Bannister in *The Long and the Short and the Tall*. (Picture reproduced courtesy of *The Press*, York, www.thepress.co.uk)

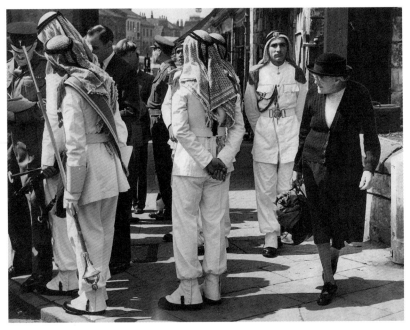

Men of the Arab Legion at the 1955 Northern Command Military Tattoo – who knows what the old lady thought of it all? (Picture reproduced courtesy of *The Press*, York, www.thepress.co.uk)

Theatre Royal and Empire apart, culture thrived in 1950s York through a plethora of arts organisations. There were at least six musical societies and orchestras: York Musical Society, York Orchestral Society, York Symphony Orchestra, York & District Organists, British Musical Society of York and the Rowntree Choral & Operatic Society. There were nine bands including York City Brass Band, York Postal Military Band and Rowntree's Cocoa Works Band. Drama too was thriving with opera and dramatic societies in Acomb and in New Earswick. There was also a community association drama group in Acomb. The Settlement Community Players and the Rowntree Players were at the fine Rowntree Theatre in Haxby Road.

In a city with such a rich history and so fertile a heritage, it should come as no surprise to find that in the 1950s there were numerous organisations working to promote and conserve that history and heritage for contemporaries and for generations to come. All did sterling work then, as now. York Civic Trust Association, York Georgian Society, Yorkshire Philosophical Society, Yorkshire

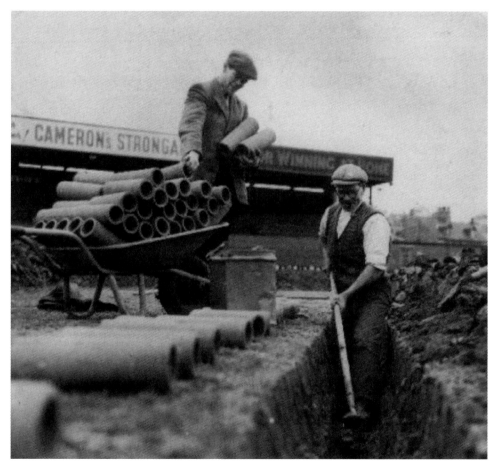

Laying drainage pipes at Bootham Crescent in 1958. (Picture reproduced courtesy of *The Press*, York, www.thepress.co.uk)

Left: The programme for the 1955 Northern Command Military Tattoo.

Below: Pipers in Petergate. Royal Scots Greys, Black Watch and the Cameronians are coming to the tattoo. (Picture reproduced courtesy of *The Press*, York, www.thepress.co.uk)

Geological Society, Yorkshire Architectural and York Archaeological Society, York Art Collectors' Society, York Art Society, York Photographic Society, York Film Society and York Science Film Society all contributed to the rich fabric of the city's magnificent culture.

But it was not all high brow and earnest: more pragmatic, caring and rehabilitation organisations also existed then such as the Borstal Association, the Infantile Paralysis Association and York Castle Discharged Prisoners Aid Society.

In 1955, York City FC were killers of giants when they defeated mighty Spurs to go on to the semi-finals of the FA Cup. Sadly, they were beaten 2-0 by Newcastle United at a replay at Roker Park. Newcastle went on to win the trophy. York had beaten Scarborough, Dorchester Town (2-5), Blackpool, Bishop Auckland, Tottenham Hotspur (3-1) and Notts County on their way to elusive glory. Arthur Bottom was top York scorer with eight goals. Arsenal were the next giants to fall to York in the 1985 FA Cup semi-final.

DRAINS, TRAINS AND CHOCOLATE

In the twenty-five years before 1959, York had an unemployment rate lower than the national average of 2.3 per cent in 1959. This had risen from 1.6 per cent in 1950 falling back to 1.7 per cent in 1960. The railways and confectionery have dominated York industrial output and employment for over 150 years. The railways, the carriage works, Rowntree's, Terry's and Craven's are synonymous with going to work in the city. During the 1950s, there were over 3,000 staff employed by the carriage works alone. There were 7,000 other employees involved in different aspects of railway business in 1959.

York's second railway station, within the walls, was used as a marshalling yard until 1959. The station was known as the 'dead-end' because traffic from Newcastle or London and from Scarborough was obliged to come into the station and reverse back out in order to continue the journey. The King of Saxony and Charles Dickens were among travellers arriving here. The current station is York's third.

The year 1951 saw the installation of a new signal box at York station in keeping with its status as the hub for railways in the north of England. The box, unobtrusively nestled between platforms 13 and 14 north of the footbridge, goes unnoticed by most passengers. In 1951, the 44-foot-long illuminated train movement panel inside boasted 867 switches, 5,410 miniature light bulbs for track circuit indications, 317 track circuits and the facility to set up 827 routes extending over 33.5 miles of track. At the time it was one of the biggest contracts ever awarded for track signalling and was the largest route relay interlocking system in the world; the cost exceeded £562,000. The huge 44-foot panel was manned by four signalmen; these are complemented by a traffic regulator and a fifth signalman who takes telephone calls. Routes can be set up with astonishing speed – a route that took up to forty lever movements with the manual system could be completed in 10 seconds with the new 1950s system.

On 1 November 1955, HRH the Duke of Edinburgh visited the carriage works. As it happened, one of the workers the prince met was Thomas Kay, a carriage washer. During the war, Kay had been chief bosun's mate on the cruiser HMS *Dido*. The *Dido* was detailed to rescue the crew of the sunken HMS *Kandahar* off the North African coast; one of the men pulled out of the water was Sub-Lieutenant Prince Philip of Greece.

The impressive hardware installed in the 1951 signal box.

On 5 August 1958, a passenger train from Sunderland, 60036 *Colombo*, crashed at speed into the buffers at Platform 12, ending up with the engine pointing up into the air, buffers touching the footbridge steps and the front engine bogie ripped off. There were no serious casualties.

Chocolate, cocoa and sugar confectionery was even bigger than the railways, with Rowntree's, Terry's and Craven's providing work for 13,000, many of them women; this amounted to 22 per cent of the city's workforce. Rowntree's alone had 10,056 workers on their books in 1958, equivalent to 10 per cent of the total population. In 1920, average chocolate consumption was around 1.5 oz a week; by 1938 the figure had nearly doubled to 2.7 oz. Confectionery consumption peaked in 1954 – the year after rationing ended – at 9.4 oz per head, falling back to 8.3 oz by 1962. National sales were £251.1 million and £290.8 million for those years. As a percentage of overall consumer expenditure, it was steady at around 1.5 per cent.

Craven's dates back to 1803 when Joseph Hick, aged twenty-nine, set up in York as Kilner & Hick, confectioners. Kilner left the business to Hick, which he then relocated to No. 47 Coney Street, next door to what was then the Leopard Inn and opposite St Martin's church. Mary Ann, Hick's youngest daughter, was born in 1829. In 1833, Thomas Craven, son of an East Acklam farmer, arrived in York aged sixteen as apprentice to Thomas Hide, his brother-in-law. Hide was running a confectionery business established in the mid to late 1820s called George Berry & Thomas Hide after the joint owners and located at No. 20 High Ousegate. Thomas Craven bought the right to trade in York when he became a

Freeman in 1840. On Hide's death in 1843 he set up his own business next door at No. 19 High Ousegate. On 1 May 1845, Craven moved the business to No. 31 Pavement, not far from the Rowntree's shop and, in 1851, he married Mary Ann Hick – she was twenty-two, he was thirty-four. In 1860, Joseph Hick died. Then in 1862, Mary Ann's husband died leaving her with three young children (one boy and two girls aged eight, six and four) to raise and two businesses to run. Mary Ann was up to the challenge; she amalgamated the two businesses, changed the name of the company to MA Craven and ran it until 1902. Production was now in Coppergate – roughly where the Jorvik Viking Centre is now – along with additional properties in Coney Street and Foss Islands Road; staff numbers had increased to 800 by 1908 – a sizeable business by York standards. There were four Craven's retail shops in the city, one of which, Craven's Mary Ann Sweet Shop, was in the Shambles and featured a sweet museum on the first floor where visitors could see 150 years of the 'Art, Trade, Mystery and Business of the Confectioner'. In 1920, the Coppergate factory was named The French Almond Works in recognition of the importance of that product line.

What was to become one of their flagship lines, Mary Anne Creamy Toffee, was launched in 1955. In 1958, the firm was supplying 8.4 per cent of total UK sugar confectionery exports to the USA, 18 per cent to Belgium and 5 per cent to West Germany. In 1957, Craven opened a shop in Shambles selling Craven's products only; a non contributory retirement pension scheme was introduced in 1954.

Riding on the success of Polo Mints, Polo Fruits were launched by Rowntree's in 1954, although these faced stiff opposition from Mars' Spangles. KitKat, facing competition from Terry's Waifa and MacDonald's Penguin, was repositioned in the marketplace to take maximum advantage of its attraction as a mid-morning snack. As a consequence, the famous slogan 'Have a break, have a KitKat' was introduced in May 1957 along with the broken bar image – all playing, of course, on the word 'break'. The Nux Bar – a combination of chocolate, hazelnuts and Rice Krispies – was introduced in 1957 and production started on St Michael's Wafers, for Marks & Spencer, using KitKat off-cuts in the factory at Tunbridge Wells.

It is no surprise that confectionery companies were among the early advertisers on commercial television on its launch in 1955. The first advertisements to show, however, were Gibbs with SR Toothpaste followed by offerings from Cross & Blackwell, and Persil from Unilever. Rowntree's was prepared for this revolution with a budget of £50,000. Some of the more memorable confectionery slogans include Beecham's Murraymints – 'the too-good-to-hurry-mints' – and, from Rowntree's, Fruit Gums – 'don't forget the fruit gums, mum.' Polar cool Polos were 'the mint with the hole'. In 1957, viewers were invited to 'have a break, have a KitKat'. By the next year, the Rowntree's television advertising budget had increased to £650,000 – half the total advertising budget. By 1958, 60 per cent of all chocolate advertising money went on TV commercials. Nationally, TV advertising accounted for 1 per cent of all advertising spend in 1955, 13 per cent in 1958 and 22 per cent in 1960.

Rowntree's Fawdon factory, 3.5 miles from Newcastle, opened in 1958 to meet the increased demand for chocolate caused by even greater disposable incomes and population increases. Cost was nearly £2.6 million with a workforce approaching 1,000 – 800 men and 200 women. KitKat continued to thrive and 14 per cent of the 1958 advertising budget of £1.8 million was allocated to the line. Sainsbury's, Tesco and groups of retailers like Spar were becoming increasingly important in the market with their focus on price and range. Rowntree's, in common with other food manufacturers, realised that they would have to adapt to provide different ways of selling, merchandising and packaging their product: the multipack was about to be born. In 1959, Caramac was launched. Nux, though, lost the battle against Fry's Picnic. Peppermint and orange Aeros came in 1959 and 1960, respectively. Cresta came in 1950, Caramac in 1959, Cracknel Bon-Bons, Toffo, Toffee Crisp, Golden Toffee Wafers, Munchies and the Weekend assortment arrived in 1957.

In 1955, Rowntree's donated the eighteenth-century iron entrance gates on Terry Avenue to remember those who fell in the Second World War 'in thanks for the courage and steadfastness of the people of York'. Fittingly, the York Peace Festival has been held in the park for the last twenty-five years.

A replica Terry's chocolate shop was opened in the Castle Museum in York in the 1950s complete with Terry's staff wearing costumes from down the ages. This was promoted by saying, 'inside there are real confections to buy and smiling wenches in period costume to offer them'. While not Quakers themselves, Terry's latched onto the temperance movement spirit when some of their chocolates carried mottos such as 'drink is the curse of the working man!' Sugar mice were specially made for the

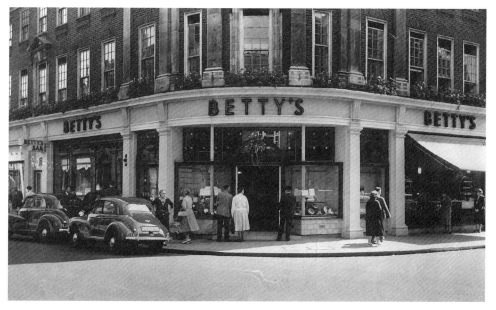

The wonderful Betty's on the corner of St Helen's Square in 1956. (Picture reproduced courtesy of *The Press*, York, www.thepress.co.uk)

replica shop and, to ensure that the chocolate smelled just right, the chief chemist concocted a 'chocolatey' potion which was bottled and kept surreptitiously under the counter. The shop featured a range of early Terry's confectionery, including Superior Nelson Balls.

Terry's Waifa bar was launched in a forlorn bid to compete with Rowntree's KitKat. When Forte took over Terry's, a Waifa bar was added to the complimentary in room tea service. Queen Elizabeth II visited York in 1957 and Terry's, Craven's and Rowntree's presented her with a joint gift of a gold and silver casket from Asprey in Bond Street, costing £38 6s 8d – to symbolize York's importance to the country's confectionery industry. The Arms of York and cocoa beans were etched onto it and the casket was filled with sweets and chocolates from all three companies.

By an amazing metamorphosis, Terry's Chocolate Orange started life as Chocolate Apple (launched in 1932 and phased out in 1954). One in ten Christmas stockings reputedly contained a Terry's Chocolate Orange during the '50s.

Love Hearts were launched in 1954 by Swizzels Ltd, an East London firm that in the Blitz of 1940 moved to New Mills, Derbyshire. Love Hearts, though, grew out of Terry's nineteenth-century Coversation Lozenges with their racy and risqué slogans such as 'Can you polka?', 'I want a wife', 'Do you love me?' and 'How do you flirt?'

There was still some light engineering in York in the 1950s. Cooke, Troughton & Simms – world-famous optical instrument manufacturers – were the most celebrated. Thomas Cooke came to York in 1829 and made his first telescope using the base of a whisky glass for a lens and a tin for the tube. In 1837, he

Three of the 'smiling wenches' waiting to meet you at the replica Terry's shop in the Castle Museum.

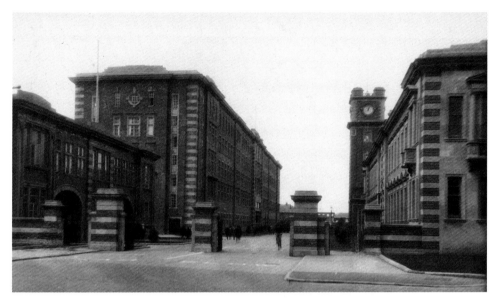

Terry's entrance.

opened his first instrument-making shop at No. 50 Stonegate with a loan of £100 from his wife's uncle. Cooke quickly gained a reputation for high quality and was soon making microscopes, opera glasses, spectacles, electrical machines, barometers, thermometers, globes, sundials and mathematical instruments, as well as telescopes. By 1844, he had expanded and moved to No. 12 Coney Street. In 1856, Cooke moved into the Buckingham Works built on the site of the home of the second Duke of Buckingham at Bishophill – one of Britain's first purpose-built telescope factories. He built a telescope for Prince Albert in 1860 and one for a Gateshead millionaire. The telescope tube was 32 feet long and the whole instrument weighed 9 tons – the biggest telescope in the world at the time. In 1893, H. D. Taylor, optical manager, designed the Cooke Photographic Lens, which became the basic design for most camera lenses thereafter. In 1866, Thomas Cooke branched out into three-wheeled steam cars, which reached the dizzy speed of 15 mph. They were, however, outlawed by the Road Act, which prohibited vehicles from travelling in excess of 4 mph. In those days it was a legal requirement that a man carrying a red flag walk in front of any vehicle not pulled by a horse. Cooke fitted his steam engine into a boat and travelled on the Ouse, blissfully free of horses and red flags. The firm moved to Haxby Road in 1939 and later became part of Vickers. Cooke died in 1868.

Adams Hydraulics made sewage lifting and purification machines and in 1959 they employed 200 people. Armstrong Shock Absorbers in Tanner Row employed some 350 people. In civil engineering, Shepherd were one of the eighty or so building firms in and around York able to take advantage of the post-war building boom. The sector employed some 5,000 workers building houses, laying drains and roads. Shepherd was one of the champions of the York Master Builders Apprenticeship Scheme 1951, one of the first

companies in the UK to respond to the government's call for mass training of builders; the last forty-two houses completed under the scheme were in Gale Lane Estate in Acomb in 1952. Ben Johnson & Co. was one of York's biggest printers working from their Boroughbridge Road factory in the 1950s. The firm was established as a lithographic printer by Johnson & John Lancaster, initially specialising in railway timetables and other jobs associated with the railways. Glass was still big in York in the '50s. The first glassworks was opened in 1794 by Hampston & Prince near Fishergate making flint glass and medicinal phials. The York Flint Glass Co. was set up in 1835 and by 1851 was a bigger employer than either Terry's or Craven's. In 1930 it was incorporated as National Glass Works (York) Ltd, which became Redfearn National Glass Co. in 1967. The year 1780 saw the establishment of John Dale's Bleasdale Ltd, manufacturing and wholesale chemists behind Colliergate. A visitor to the firm in the 1950s would also have seen barrels of black beer, cod liver oil and machinery for grinding liquorice, trimming rhubarb and grinding poppies. There was also Raimes & Co. from 1818 in Micklegate and Henry Richardson & Co., fertilizer makers founded in 1824 at Skeldergate Postern in Clementhorpe. British Sugar opened a factory at Poppleton in 1927 and were taking on 350 mainly seasonal workers for the beet harvest, in the '50s. Plastics occupied a further 350, mainly women workers. The Yorkshire Insurance Co. opened offices in York in 1824 and were significant employers in the 1950s at a time when shop and warehouse workers made up 10 per cent of the working population in the city's 1,500 shops and warehouses, while 2,300 people worked in catering and hospitality business.

In 1951, the overall pattern of employment in York had changed very little since the beginning of the century; confectionery and the railways still accounted for 30 per cent of all jobs. The only exception was domestic service. Since the demands on women during the First World War and the increasing availability of better paid work (not least in chocolate and in trains), jobs in this sector shrank to 690 (1.3 per cent of total workforce) in 1951 from 3,810 (10.3 per cent) in 1911. Other small rises took place in education services (1,320 – more new schools), medical services (1920 – the NHS and more doctors and nurses), national and local government, garages and motor servicing and repair (1,120 – the rise in car ownership) and banking and insurance.

Manufacturing occupied 19,080 workers, construction 3,250, utilities 1,000, transport and communication 8,200 including 1,200 at the Post Office; distribution 6,820, hotels and pubs 2,200; defence 1680. The year 1958 saw a huge number of soldiers stationed in York when two Yorkshire regiments were amalgamated and part of Fulford Barracks closed – the West Yorkshire Regiment Prince of Wales's Own (14th Foot) merged with the East Yorkshire Regiment (15th Foot) to form the Prince of Wales's Own Regiment of Yorkshire.

In Sickness and in School

In 1959 there were 3,424 hospital beds in York within a 5-mile radius of the centre of the city – of these 1,300 were in the city centre. In the 1950s, York's oldest hospital was County Hospital in Monkgate – the third such institution on the site. The sick in '50s York, then, had a plethora of hospitals at their disposal. In addition, some of the almshouses were still open to the needy. After the National Health Service was set up in 1948, thirteen York medical institutions came under the control of the York 'A' and Tadcaster Hospital Management Committee. They were two general hospitals (the county and the city), two mental health hospitals (Bootham Park and Naburn), the maternity hospital at Acomb, Yearsley Bridge infectious diseases hospital, the tuberculosis sanatorium at Fairfield and the Grange Hospital for the elderly. The York Dispensary was not part of the health service and became a health centre in the 1950s.

In 1950 the general hospitals were supplemented by a civilian wing at the military hospital. In 1952 Bootham Park and Naburn were amalgamated and two new hospitals were opened in 1954 – Fulford Hospital (General) and the adjacent maternity hospital. In 1955 the Grange Hospital was renamed St Mary's Hospital.

Under the National Health Service Act, the corporation had to provide child welfare, midwifery, health visiting, home nursing, vaccination, immunization, ambulance and other services, all of which were made available at the Duncombe Place health centre – the former York Dispensary – and at Gale Lane health centre in Acomb, as well as child welfare services in seven extra clinics. Other clinics included the Birth Control Clinic in St Saviourgate, the Diptheria Immunisation School clinic in Rougier Street and the TB Service in Castlegate.

For dogs and cats, the journey to Foss Basin was strictly one way. Vividly called the Lethal Chamber, this facility was run by the RSPCA for the humane destruction of cats and dogs – Cats cost 1s and dogs half a crown.

In the 1950s, there were still nine almshouses, or hospitals, operating – they are listed below:

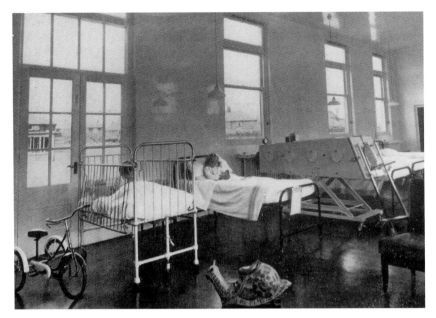

The children's ward showing polio patients at Yearsley Bridge with toys and iron lung. The saddest picture in this book. (Picture reproduced courtesy of *The Press*, York, www.thepress.co.uk)

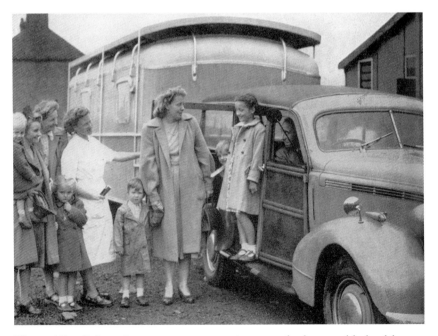

The mobile clinic arrives – an attempt to improve the lamentable health care provision that prevailed at the time for patients in rural areas. The first step was this mobile maternity and child welfare unit, which comprised the well-equipped, heated, two-room unit complete with doctor, nurse and a vehicle to tow it. The truck also brought patients from the more isolated farms and hamlets.

Ingram's Hospital, Bootham

An almshouse for ten poor widows built between 1630 and 1640 by Sir Arthur Ingram (d. 1640), a Leeds-born linen draper from London who bought the manor of Temple Newsam and built the house there. He was MP for York four times – first in 1623 – and High Sheriff of the County in 1620. Fire damage to the buildings during the Civil War Siege of York was restored in 1649. The hospital comprises eleven bays of two storeys with a four-storey central tower. The middle doorway dates back to the Norman period and was removed from Holy Trinity priory on Micklegate. Charles I stayed at the hospital in 1642. It was converted into four flats in 1957, somewhat unsympathetically destroying the interiors, bricking up the large glass window at the back and indiscriminately adding other windows.

Old Maids' Hospital, Bootham

What is now Wandesford House – the Old Maids' Hospital (or the Protestant Old Maids' Hospital) – was left as a bequest by Mary Wandesford in her will of 4 November 1725 and built in 1743. As with many almshouses, it was called a hospital before 'hospital' acquired connotations of medical care. Today it comprises twelve flats for single and needy or distressed Christian women over fifty years of age. The original bequest involved an estate at Brompton-on-Swale worth £1,200, with another £1,200 in South Sea Stock in trust:

> for the use of ten poor gentlewomen who were never married and who shall be of the religion which is taught and practised in the Church of England as by law established, who shall retire from the hurry and noise of the world into a religious house of protestant retirement which shall be provided for them and they shall be obliged to continue there for life.

Dame Anne Middleton's Hospital, Skeldergate

Funded by a £2,000 endowment given by Dame Anne Middleton in 1659, the hospital was originally a refuge for twenty widows of the Freemen of the City of York. It was later rebuilt and extended in 1829. The niche above the front door contains the full length painted statue of Dame Anne in Puritan dress from the building of 1659. St Stephen's Orphanage was founded in the 1870s – originally in Precentor's Court moving to Trinity Lane and then to the Mount in 1919 – and it closed in 1969. The orphanage occupied a holiday house in Filey. The others were as follows: Thomas Fothergill Homes, Avenue Road, Clifton; St Catherine's Hospital, Holgate Road; St Thomas's Hospital, Nunnery Lane; Terry's in Skeldergate; Sir Roland Watters Hospital in George Street; and Sister Wilson's House in Heworth.

Duncome Place Health Centre

Before the establishment of the NHS, the York Dispensary was set up to look after York's sick poor; County hospital had no remit there. It was originally in the Merchant Adventurers' Hall, moving to St Andrewgate and then, in 1828, to New Street. The next move was to the imposing red-brick building in Duncombe Place in 1851. Its noble mission, as recorded in *Baines' Directory* for 1823, was 'to dispense gratuitously advice, medicine and surgical assistance, to those who are unable to pay for them'. Medicines were free of charge. In the '50s services such as child welfare, midwifery, health visiting, home nursing, vaccination, immunization and ambulances were run from here after the corporation bought the building. The directors of the dispensary were not going to give up 160 years of continuous voluntary service lightly; they were keen to continue with their charitable work and formed a charitable trust in 1948, which led to the York Dispensary Sick Poor Fund in 1955. This led to the provision of special food and medicines, bedding, fuel, medical and surgical appliances and domestic help for the sick and convalescing poor. In addition, the fund made financial contributions to local charities such as Age Concern York, York Spastics Society and St Leonard's Hospice.

County Hospital

York County Hospital started life in a rented house in 1740 in Monkgate. Before that, from 1614, the city surgeon was responsible for medical care. In 1745 a purpose-built hospital opened on the same site with fifty beds treating 2,417 patients by 1750. As a charitable Hospital (where the financiers could choose who received treatment there) County Hospital was, as we have seen, not responsible for the city's sick poor; this led to the establishment of the dispensary. The 1745 hospital building was demolished in 1851 and replaced with a new 100-bed hospital costing £11,000. In 1887 it merged with the York Institution for Diseases of the Eye that had been established in the Merchant Tailors' Hall, Aldwark, in 1831 for poor patients. A similar facility for ear diseases was opened in 1851 moving to the Merchant Adventurer's Hall in 1855. The present 600-bed York District Hospital opened in 1976 replacing the seven hospitals available in the '50s – County Hospital, Fulford Hospital, Deighton Grove hospital, Yearsley Bridge Hospital, Acomb Hospital, the Military Hospital and City Hospital.

The City Hospital, Haxby Road

Opened in 1941 to provide 360 beds, but in fact only 180 opened along with seventy-six more in the convalescence annexes.

St Mary's Hospital, Haxby Road

Next door was St Mary's, catering mainly for the elderly with 263 beds. It was originally called the Grange Hospital and grew out of the infirmary at the York Workhouse on Huntington Road, which later became a city institution for the aged poor.

York Lunatic Asylum and Naburn Hospital (York City Asylum)

Built by John Carr, the lunatic asylum opened in 1777 in Bootham with fifteen patients – rising to 199 by 1813. The asylum's mission was to be caring 'without undue severity'. It advertised that 'patients are admitted according to their circumstances, the terms for pauper patients belonging to the City, Ainsty and County are 8 shillings per week'. Part of the asylum burnt down in 1814 with the tragic loss of four patients and patient records, somewhat convenient, perhaps, as the fire coincided with allegations of mismanagement of the asylum and with the rise of the Retreat – a very different type of psychiatric hospital. All staff were dismissed and replaced. In the same year a visiting magistrate had reported that the 'house is yet in a shocking state ... a number of secret cells in a state of filth horrible beyond description' and the floor covered 'with straw perfectly soaked with urine and excrement'. In 1904 it was renamed Bootham Park Hospital. In the 1950s there were 657 beds shared between here and Naburn Hospital where 455 of the beds were – York's third psychiatric hospital. Clifton Hospital was the city's fourth psychiatric hospital in the '50s. It was built in 1847 and had 1,140 beds.

The Retreat

In 1796, William Tuke founded the Retreat in which he pioneered a revolutionary way of treating the mentally ill – namely, humanely. This was in stark contrast to existing methods that regarded patients as being in possession of demons and chaining them up as criminals – prisoners rather than patients in a squalid, punitive environment. Tuke wanted 'an institution for the care and proper treatment of those labouring under that most afflictive dispensation, the loss of reason'. His resolve was triggered when the relatives of a Quaker patient, Hannah Mills, were refused visiting rights to the York lunatic asylum after Hannah's death there – Hannah had been shackled. A delegation of Quakers obtained permission to visit and inspect. The thirty-bed Retreat was the result and it laid the foundations for the modern treatment of psychiatric disorders and patients. The Retreat continues to serve the needs of the psychiatric patient today and remains a prestigious centre of excellence.

York Fever Hospital and Fairfield Sanatorium, Skelton

Opened in 1880 at Yearsley Bridge, it was primarily focussed on patients
with scarlet fever, smallpox, typhoid and diphtheria. In 1902, the Bungalow,
a smallpox hospital in Huntington, was opened as an annexe. The
seventy-four-bed Fever Hospital closed in 1976 and was demolished in 2008.
Fairfield Sanatorium had a further sixty-eight beds for TB patients.

Fulford Hospital and the Maternity Hospital, Fulford

Opened in 1954 with 149 and 108 beds, respectively, on land next to Naburn
hospital, which had previously been the site of a wartime emergency medical
service hospital.

Purey-Cust Nursing Home

This grew out of the need to increase the inadequate accommodation at the
District Nurses House at No. 37 Monkgate. It is named after Dean Purey
Cust – dean of York Minster for twenty-five years. It opened in 1923 and had
eighteen beds in the '50s. It closed as a nursing home in 1955.

The year 1951 saw the introduction of GCE O and A levels, replacing the
old School Certificate. There were 14,909 pupils in primary and secondary
education in York. In 1959, no fewer than eight of the thirteen secondary
modern schools in York had been built post-Second World War, reflecting
the national upsurge in education provision; GCE courses began in 1959
at the secondary moderns. There were six grammar schools for those
who passed their eleven-plus – Nunthorpe County Grammar; Archbishop
Holgate with 520 boys in 1956; Bar Convent; and, for girls, Mill Mount
County Grammar, Queen Anne County Grammar and St Margaret's
Independent Grammar School for Girls where, in 1957, 188 girls aged five
to seventeen were attending the school with ten boys under eight in an
infants' department. After the Second World War the tragically bombed Bar
Convent was extended with the addition of seven classrooms, a laboratory,
a needlework room and a dining room. In 1954, there were 321 girls in the
school and 16 boys in the preparatory department; there were 4 girl boarders
in 1957. Private education in the 1950s was catered for by St Peter's (one of
England's, indeed the world's, oldest with 330 boys in 1956), the Minster
School and the two famous Quaker schools, Bootham and, for girls, the
Mount. York College for Girls was in 1956 described as an independent
day and preparatory school. At the Mount, accommodation was increased
to meet the needs of 240 boarders in 1956. At Bootham numbers increased to
240 in 1956 when all were boarders except seven boys; the school was

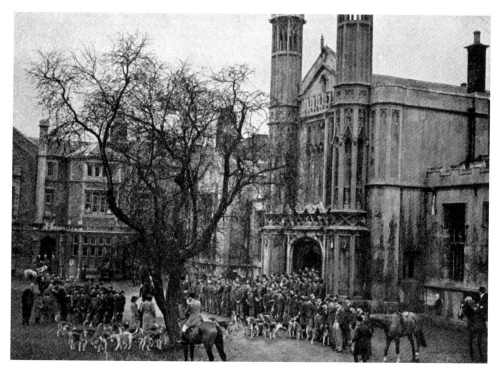

The York & Ainsty Hunt meeting at St Peter's.

all boys in the 1950s. Old Peterites active in the '50s and '60s include Christopher Hill, Marxist historian; Harry Gration, TV presenter; and John Barry, film score composer of eleven James Bond soundtracks, *Midnight Cowboy, Born Free* and *Out of Africa*. From the Mount are actors Mary Ure and Dame Judi Dench, the three Drabble sisters – writers A. S. Byatt and Margaret and art historian Helen Langdon – and astronomer Jocelyn Bell Burnell.

It is interesting to review the occupations of some of the parents of pupils attending the Minster School in the '50s. Fathers were coach builders, train drivers, bus drivers, taxi company owners, brewery office managers, BR motive power supervisors, BR welders, company directors, paint company reps, potato merchants, market garden workers, wine and spirit merchants, decorators, jewelers, journalists, engineers, mechanics, electricians, railway workers, teachers, headmasters and quantity surveyors. Mothers were housewives (most), shop assistants, cinema usherettes, Rowntree's office workers, head of sales at Rowntree's, nurses, hotel cooks, teachers (a number), secretaries, professional actresses and accounts clerks – the whole gamut of occupations, perhaps surprisingly, with diversity among women as well as men.

There were other educational establishments outside the state system. These included Haughton School in St Saviourgate, founded in the eighteenth century by William Haughton and run as a trust, Premier Commercial School in Low Ousegate offering courses in shorthand, typing, bookkeeping and spelling,

Grey Coats for Girls in Monkgate and the Settlement in Holgate Hill, set up to inculcate a 'spirit of fellowship' and teach such things as folk dancing, handicrafts and modern languages. For adults there was the Railway Institute, the Workers' Educational Association and the York Co-op Society Educational Department.

One of the less well-known by-products of the Industrial Revolution was an upsurge in the demand for and provision of adult education:

> As a consequence of the introduction of machinery a class of workmen emerged to build, maintain and repair the machines on which the blessing of progress depended, at a time when population shifts and the dissolving influences of industrialization in the new urban areas, where these were concentrated, destroyed the inadequate old apprentice system and threw into relief the connection between material advancement and the necessity of education to take part in its advantages.

This, of course, was before the Carnegie libraries and the introduction of public libraries. The Quakers were at the forefront of this movement with their highly organised adult schools and the sport and social facilities and continuing education they provided for their workers in industrial villages such as New Earswick and Bournville. Mechanics' institutes were important too. The aim of mechanics' institutes was to provide a technical education for the working man and for professionals to 'address societal needs by incorporating fundamental scientific thinking and research into engineering solutions'. They transformed science and technology education for the man in the street.

Mechanics' institutes provided free lending libraries and also offered lectures, laboratories and, occasionally, as with Glasgow, a museum. The York Institute had its stimulus from a Whig newspaper article about the London Society for the Diffusion of Useful Knowledge. The Tories, on the other hand, were paranoid and suspicious of the 'efforts to awaken the dormant powers of the mind in the middling, but more especially in the lower classes of society'. Nevertheless, York opened in 1827 in Bedern with a membership of 272; appeals for books for the library produced over 500 by the end of the year. The Institute struggled, though, and, as elsewhere, did not hold the attraction for the working classes the founders hoped it would. Indeed, the 1834 writers of the annual report were naively indignant about the local lack of support for an institute they foolishly said was 'designed and adapted to check the progress of frivolity, dissipation and vice' – so unintentionally aligning it with the Quaker supported York Society for the Prevention and Discouragement of Profaneness and Vice (lewdness, brothel-keeping, intoxication, swearing and Sabbath-breaking). This, in turn, was lampooned as a society for the suppression of the 'vice of persons whose income does not exceed £500 per annum'.

The institute was not a success for the simple reason that its agenda was at odds with the needs of its students: 'values and ideals which were totally out of touch with the reality of the lives of its students. Much of its curriculum was beyond the comprehension and ability of most of its pupils.'

In 1838 the institute changed its name to reflect a new focus and became the York Institute of Popular Science and Literature, housed in St Saviourgate. Lectures became more populist; they included phrenology and one on Phineas Taylor Barnum in 1855. Musical entertainment was introduced in 1846. The evening classes, though, were always a success; Society of Arts examinations were taken from 1851 leading to the opening of the Institute School of Art in 1881 in King Street. City and Guilds technical examinations and commercial examinations of the Yorkshire Union of Mechanics' Institutes were also introduced. These paved the way for the institute to transform itself into a technical college, which is what it became when it moved into a building in newly built Clifford Street in 1885.

In 1889 York Railway Institute was opened on the back of all this on the site of the Railway Tavern to provide educational and recreational activities for the railway workers of York. It survived and thrived throughout the '50s and today has over 3,000 members in activities ranging from sailing, golf, judo, dance, Pilates, and yoga to brass bands, theatre, chess and dominoes.

In 1889 the library at the institute was the only accessible public library in York, which goes a long way to explaining its popularity. The Minster Library was academic and specialised; the Subscription Library demanded an expensive entrance fee of 10 guineas and an annual membership charge of 1s 6d – circulating libraries and the York Institute library seemed to have been the preserve of the middle classes. The Corporation free library did not open until 1893. The 9,223 inaugural collection of books at the institute was very soon complemented by a further 543 volumes. Half of the books were novels 'but the cheap sensationals were eschewed, while prominence is given to the best authors such as Lytton, Scott, Eliot, Dickens and Trollope'– science, history, geography, travel and biography sections were strong. Lenders were unable to select from shelves, as we are used to doing today. Instead, a list of six books had to be handed in, selected from the catalogue. In the first six months an astonishing 23,715 books were borrowed from the new library – twice that at the old library.

The reading room was open from 8.00 a.m. to 10.00 p.m. and at the end of the First World War it offered twenty-three daily newspapers, both local and national, fifty-eight weekly papers and forty-five monthly magazines on a wide range of subjects. One of its international papers, the *Detroit Free Press* must have been much in demand.

Lectures too were diverse (some my say perverse) in subject. Over the years they were often augmented with magic lantern images. The more riveting lectures included 'A Temperance Tour Around the World' by Fielden Thorpe, Quaker head of Bootham School, 'How I Walked to Monte Carlo' by the Revd AN Cooper and, much more interesting, 'The Volcanoes of Central America' by the distinguished York vulcanologist Tempest Anderson. The York Railway Lecture and Debating Society was formed in 1904 and was extremely popular with debates on railway organisation and management. The year 1926 saw the redundant carriage-building shops on the Queen Street site converted

Mr Camidge takes a PE lesson at the Minster School in front of the minster and then escorts choristers to Evensong (*below*) – both in 1951.

Far right: Judith Dench as Titania in a performance of *A Midsummer's Night Dream*. Susan Drabble was Hippolyta and her sister Margaret was Moth.

Right: Here she is again at the 1957 performance of the Mystery Plays, aged twenty-two. Nine Mount girls performed in Benjamin Britten's *Noye's Fludde* in the minster in 1959.

Below: Queuing up for ice cream at a school fete from a shrewd delivery service to the Mount School soon after the end of rationing.

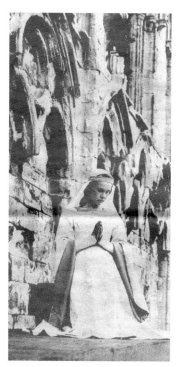
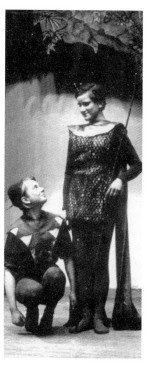

into a large gymnasium. Boxing was particularly popular; in 1920 the York Railway Institute Golf Club was formed with a nine-hole course at Hob Moor. Membership was restricted to 200 'railway employees' and twenty-five 'outside members'. By 1939, membership stood at nearly 4,000. The demise of the educational role coincided with the new obligations imposed on corporations to provide educational facilities for all of its citizens. There ended a fine, prestigious and successful service of further education provided by York railways. In the end, the 234 ladies got their own reading room away from the men; they must have been so grateful to share the nine magazines and periodicals specially stocked for them – out of a total of seventy-four. Other libraries in York in the 1950s were York Public Library with an exemplary local history section comprising 4,000 volumes. It also boasted the Sir John Marriott Medical Library donated in 1945. There was also the York Preparative Meeting Library in the Friends' Meeting House.

The Yorkshire School for the Blind at the King's Manor

Mr Lumley's Boarding School for Ladies was here from 1712 to 1835 and then the William Wilberforce inspired Yorkshire School for the Blind in 1833 who, from the 1870s, gradually restored and enlarged the buildings, adding a

The photograph shows a cricket game for the boys and girls of the school in 1947. The ball had a rattler on it and the umpire blew a whistle to communicate his decisions. (Picture reproduced courtesy of *The Press*, York, www.thepress.co.uk)

gymnasium and a cloister to create a second courtyard. The blind school left in 1958 and the pupils were transferred to a similar school in Newcastle. The manor was then acquired by York City Council, who leased it to the University of York in 1963.

Joseph Rowntree School

The Joseph Rowntree Secondary School was opened on 12 January 1942 by Rab Butler to cater for 480 children from New Earswick, Haxby and Wigginton and the surrounding area. As with the earlier primary school in the model village it was nothing if not innovative for its time, taking advice, for example, from the National Institute of Industrial Psychology on ergonomic matters such as ventilation, heating and lighting. From the very start practical skills were valued and taught in equal measure to academic subjects.

The old pictures are taken from the 1946 school prospectus. Domestic science in the 1940s and '50s included cooking by electricity, gas or coal, working in the domestic flat adjacent to the department and used by the domestic subjects mistress, assisting in the village nursery school and feeding the animals. The original school was designed as an open-air building and innovations

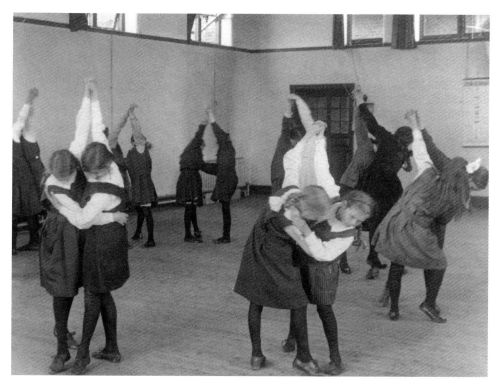

Dancing lessons at Joseph Rowntree School. (Photograph courtesy of *The Press*, York, www.thepress.co.uk)

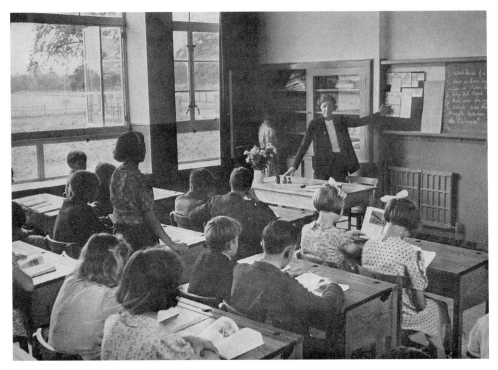

A lesson at the progressive Joseph Rowntree School.

included south-facing large windows low enough for pupils to see out of when at their desks, 'capable of any required degree of opening' depending on the weather or time of year to provide optimum ventilation and lighting, ceiling heating panels and 'the long principal corridor (which) is slightly curved so as to minimise noise transmission by means of skin friction'. The garden comprised 2 1/2 acres and included a demonstration orchard to teach the principles of fruit cultivation. There were also 2 further acres for raising livestock and an apiary.

York Technical College and the School of Art

There were 1,045 part-time day and evening students enrolled in 1949 – 452 were enrolled for day classes and 1,395 for evening classes. For the artistic there was also the School of Art and Technical College in St Leonard's.

Fulford Road School for Delicate and Partially Sighted Children

In 1913, an open-air class was started at No. 11 Castlegate in the same building as the Tuberculosis Dispensary; the classes were held in the garden. There were thirty-nine pupils in 1919. The following year the school moved to a converted army hut in the grounds of Fulford House and became known as Fulford Road School for Delicate and Partially Sighted Children. By 1925 there were

116 children enrolled and in 1956 the figure had fallen slightly to 108. The Holgate Bridge School for Mentally Defective Boys was opened in 1911 on a temporary basis, with provision for seventy boys. In 1923 they moved to Fulford House, later known as Fulford Road School for Educationally Sub-Normal Children, where there was residential accommodation for sixty-two boys and forty-one girls. In 1956 there were ninety-nine children enrolled. At Fulford Cross there was also the Open-Air School and the Class for Partially Sighted Children. The Fairfield Sanatorium Special School was in Skelton Road.

St John's College

What was then grandly known as the York and Ripon Diocesan Training College for Schoolmasters opened its doors in May 1841 as a residential training school for the diocese of York. The premises were those previously occupied by the Manchester College in Monkgate and were purchased by the Diocesan Board of Education for £3,100. An arrangement made in 1843 found the college supported equally by the diocesan boards of York and Ripon and to train schoolmasters for national schools in both dioceses. The 1950s saw considerable development at what is now York's 'other university'. Teaching and residential accommodation were increased by annexes in Gray's Court in 1946, Heworth Croft in 1950 and The Limes in 1953. A biology laboratory was built in 1950, a library in 1952, a lecture theatre in 1954 and an arts and crafts block in 1955. In 1956 there were 267 students.

PRESERVING YORK'S PAST – 'THE CITY OF OUR DREAMS'

Beware how you destroy your antiquities, guard them with religious care! They are what give you a decided character and superiority over other provincial cities. You have lost much, take care of what remains.

William Etty (1787–1849)

The Castle Museum was established by the corporation as The Folk Museum of Yorkshire Life in John Carr's Female Prison by the castle in 1938; its purpose was to house a magnificent collection donated to the city by Dr J. L. Kirk, a Pickering GP. The extensive collection included farm machinery, fire insurance signs, musical instruments, furniture, entire shop fronts, a hearse, two fire engines and a Hansom cab. So much was there that it took three years to move it all to York. The items brilliantly adumbrate aspects of York and Yorkshire domestic and social life from the seventeenth century onwards and include period rooms and a York 'street' (Kirkgate) faithfully reconstructed from demolished property. In 1952 the Debtors' Prison was opened up to form an extension for the museum containing craft workshops, a collection of costumes and a military section. Today, the museum has much dating from the '50s, including a sitting room reconstruction and a 1940s kitchen, of which most of the contents would have still been in use in the '50s.

Following the success of a Railway Centenary Exhibition held in York in 1925, a railway museum was opened in 1928 in Queen Street. In 1953 the museum fell under the auspices of the British Transport Commission's curator of historical relics and was later repurposed as a North East regional collection. Eventually this led to the National Railway Museum being established in York. In the 1950s the collection comprised a few railway carriages, eleven locomotives and, the pièce de résistance, the world's first iron railway bridge – the Gaunless Bridge at West Auckland on the route of the Stockton & Darlington Railway built by George Stephenson originally for horse-drawn traffic. In 1955 a branch office of British Transport Historical Records was established at York with facilities for transport and railway research.

The Guildhall was reduced to rubble and a burnt-out shell in the Baedeker raid of 1942. In 1956 a decision was made to restore the building to its former glory. The War Damage Commission paid a large part of the bill and work began in 1958.

The reconstruction of the living room (*above*) and kitchen (*below*) in the Castle Museum. (Images courtesy of York Museums Trust, www.yorkmuseumstrust.org.uk/)

The Old Palace not only houses York Minster's library and archives but also the Collections Department and the conservation studio. It is known as The Old Palace because part of the building used to be the chapel of the thirteenth-century Archbishop's palace. In 1810 it was refurbished and, shortly after, the minster's collection was installed there. The original library was the dream and ambition of King Egbert, a disciple of the Venerable Bede. He opened a school of international repute and started a collection of books. The librarianship then passed from 778–81 to Alcuin – one of the architects of the Carolingian Renaissance. Alcuin's catalogue featured works by many of the church fathers and classical authors such as Pliny, Aristotle, Cicero and Virgil, but all was tragically lost when the minster and library were sacked by the Vikings.

The Yorkshire Architectural and York Archaeological Society have been tireless stalwarts in the preservation of all good things in York. Apart from archiving and digitizing the wonderful photographic collection of W. A. Evelyn, which illustrates York and York life in the early twentieth century, in 1951 it successfully canvassed for the restoration of the often overlooked Norman house off Stonegate (York's oldest dwelling). It also stopped the transfer of probate records of York to the central register in London and, unsuccessfully, fought hard for the preservation of St Mary, Bishophill Senior.

In 1951 during York Festival, the York Georgian Society completed the restoration of the Assembly Rooms (used as the Food Office until 1950) and held a Georgian ball there to celebrate their magnificent achievement.

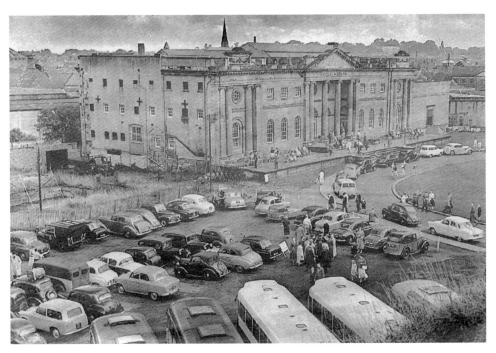

A busy day at the Castle Museum.

Suggested water garden surrounding Clifford's Tower by R.J. Sawyer as part of the 1948 York Report published in J.B. Morrell's *The City of Our Dreams* in 1955 – 'a plan for the progress and preservation of the City of York.'

In 1951 York Civic Trust leased St Anthony's Hall from the city council, restored it and made it a home for a Repository of Historical Muniments where the Diocesan and Provincial Archives were kept under the auspices of an archivist. The Princess Royal opened what became the Borthwick Institute of Historical Research in 1953.

That same year, the York Institute of Architectural Study was formed. In 1955 they moved into St John's church on Ouse Bridge, but not before they had saved it from destruction and restored it. The institute became the York Academic Trust soon after. In 1959 the trust set up the University Promotion Committee and began its wooing of the University Grants Committee in earnest; the outcome was, of course, the long-awaited and much-needed University of York.

Patrick Nuttgens, in his celebrated *The History of York*, describes York in 2007 as 'the most celebrated centre of conservation and environmental prestige in the country and possibly in Europe ... a visible three-dimensional complex of monuments and a city centre of supreme quality'.

While this is not the York we remember from the 1950s, it is certain that the seeds of the city's internationally recognised prestige, quality and celebrated status were sown in the often gloomy and grey years of 1950s – the decade that changed a city.

Sawyer's depiction of the 'Suggested position of "Parliament House" to form an entrance to the Castle Museum, from the same source.'

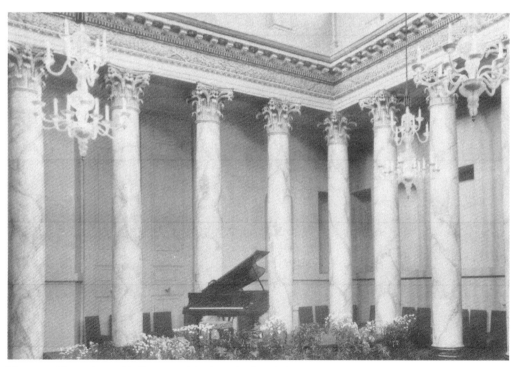

The magnificent Assembly Rooms with piano in the 1950s.

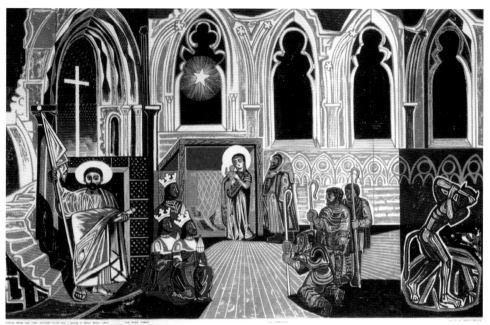

Above: Promoting York and its history in BR posters from the 1950s.

Right: The jacket of Nuttgens' *The History of York* showing Clifford's Tower as painted by L. S. Lowry, published by Blackthorn Press, Pickering. The painting now hangs in the York City Art Gallery. (Image courtesy of York Museums Trust, www.yorkmuseumstrust.org.uk/)

Acknowledgements

Many of the images in the book are mined from the superb archive of photographs held by *The Press* in York. My thanks then go out to Anne Green, Steve Lewis and Perry Austin-Clarke for their generosity and all the hard work they put into sourcing and reproducing the pictures for me – not for the first time. The pictures are theirs but the captions are all mine, so any errors of fact are entirely my fault. You can see, or add to, the archive at www.thepress.co.uk/memories.

Thanks also go to Sarah Sheils at the Mount School for permission to quote from and use images from her book, *Among Friends: The Story of the Mount School, York* (London, 2007). John Roden was kind enough to give permission to use the Minster School photographs originally published in his *The Minster School, York: A Centenary History, 1903–2004*.

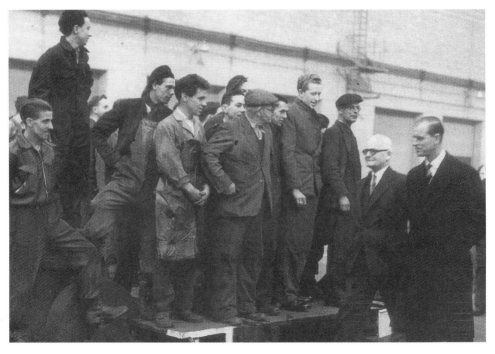

Royal visit in 1955: the Duke meeting lift shop staff.

ABOUT THE AUTHOR

Paul Chrystal was educated at the Universities of Hull and Southampton where he took degrees in Classics. He has worked in medical publishing for thirty-five years, but now combines this with advising local visitor attractions such as the National Trust in York and York's Chocolate Story, writing features for National newspapers and appearing regularly on BBC radio and on the BBC World Service. Paul is married with three children and lives near York.

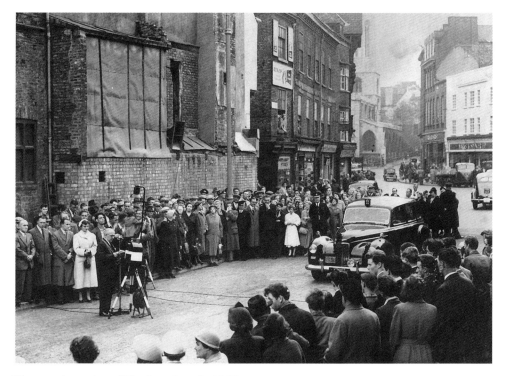

The grand opening of The Stonebow in 1955.

By The Same Author

The Rowntree Family

A History of Chocolate in York

York Industries

Confectionery in Yorkshire

Secret York

A–Z of York

York in the 1960s and *York in the 1970s* are due for publication in late 2015 and mid-2016, respectively.